IMAGES
of America

VERMONT
COVERED BRIDGES

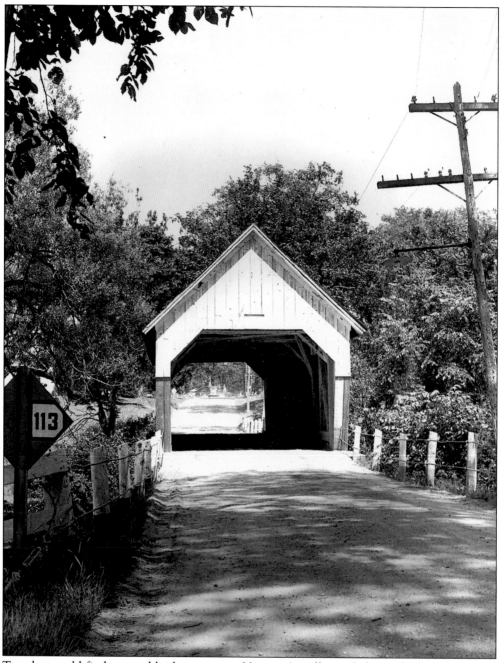

Travelers could find covered bridges even on Vermont's well-traveled state highways into the 1950s. Post Mills Bridge crossed the Ompompanoosuc River on state Route 113 in Thetford until 1952. (Raymond Brainerd, July 3, 1939.)

IMAGES
of America

VERMONT
COVERED BRIDGES

Joseph D. Conwill

ARCADIA
PUBLISHING

Published by Arcadia Publishing
Charleston, South Carolina

Printed in the United States of America

Library of Congress Catalog Card Number: 2004103260

For all general information contact Arcadia Publishing at:
Telephone 843-853-2070
Fax 843-853-0044
E-mail sales@arcadiapublishing.com
For customer service and orders:
Toll-Free 1-888-313-2665

Visit us on the Internet at www.arcadiapublishing.com

*Dedicated to the memory of Justus "Jock" Baldwin Lawrence, who
greatly encouraged the author's photography in the early days.*

CONTENTS

ACKNOWLEDGMENTS

Vermont Covered Bridges draws from the work of many people. Richard Sanders Allen is the dean of covered bridge historians. He has been an immeasurable help, both by way of his historical research and by the photographs he took during his travels in the 1930s and 1940s. Raymond and Barbara Brainerd and Henry A. Gibson sought out covered bridges during the same period, as did Herbert Richter a decade later. All of these photographers have generously donated their collections to the archives of the National Society for the Preservation of Covered Bridges, from which this book was drawn. The society will receive the royalties from sales of this book.

INTRODUCTION

Vermont is the state most people associate with covered bridges. Pennsylvania and Ohio have more of them, but Vermont is a small place and the state's 100 existing covered bridges are very visible. Exactly how many were built will never be known but probably at least 700; Windsor County alone had over 100.

The archival record reflects this richness. Travelers began recording Vermont's covered bridges before 1930. Many of their photographs survive, along with the original negatives. The challenge is not in finding the images but in deciding which ones to choose. For this book we selected views that are not likely to be found in other sources.

Many of the photographs show a landscape of great beauty, which readers may think never existed in reality. Such was most of Vermont in the first half of the 20th century. It is a mystery why so many people today dismiss beauty as impossible or deride it as sentimental. In Vermont, perhaps more than anywhere, there has been an appreciation of the old rural landscape. Agriculture made it possible, and the economy now works strongly against most farmers. The means of earning a living today do not work in favor of rural preservation. There is no reason why new construction should ruin the old, but most of what is built in what was once the country is clearly of suburban rather than of rural inspiration, even in Vermont.

The covered bridges still remain as reminders of the old rural culture. They were built of wood and roofed to protect the structural timbers from rot. Long ago they served cities too, but mostly the rural examples are what remain, and in the popular imagination, the covered bridge is a powerful symbol of country life.

The first known American covered bridge was completed in Philadelphia in 1805, but the idea did not reach Vermont until the 1820s. By then, designers had developed several different truss types for construction, and the later 19th century brought further improvements. Styles of medieval origin, such as the queenpost, were widely used for shorter spans. For longer bridges, the Burr truss had a multiple kingpost frame with vertical posts, and braces between them inclined toward the center. A timber arch was bolted to this, which is the most obvious feature of the design, and it proved popular in much of central and northwestern Vermont. The Town lattice truss used a lattice of sawn planks pegged together with wooden treenails (pronounced trunnels). Widely used in Vermont, it was found everywhere in the southern part of the state and in various parts of the north. A rare and interesting variant used squared notched timbers instead of flat planks, and although there were only seven known examples, this type was given so much attention by earlier writers that it is sometimes locally regarded as another major

style. Peter Paddleford of nearby Littleton, New Hampshire, developed a special truss using an elongated counter tie to help distribute the load. It was often used in northeastern Vermont.

The Howe truss, first patented in 1840, introduced adjustable iron tie rods and was a distinctly modern innovation. It was widely used for railroad bridges in the state but found only a spotty acceptance for road bridges among Vermont's conservative local builders. Several later and very efficient designs, such as the Smith truss, appeared elsewhere in the second half of the 19th century, but they never received any foothold in Vermont, where officials preferred the tried-and-true earlier designs.

A complete history of all of the covered bridges ever built in Vermont would amount to an encyclopedia and is well beyond the scope of this modest volume. Richard Sanders Allen wrote two excellent and complete county histories, both published by Stephen Greene Press in Brattleboro, which are now out of print: *Rare Old Covered Bridges of Windsor County, Vermont* and *Windham County's Famous Covered Bridges*. The latter was based on a series of newspaper articles by Victor Morse, published in the *Brattleboro Daily Reformer* in the 1930s. Allen's *Covered Bridges of the Northeast* is happily back in print. For a general history of covered bridges in the United States and Canada, readers may consult my *Covered Bridges Across North America* (St. Paul, Minnesota: MBI, 2004). Joseph C. Nelson and Ed Barna have both written on Vermont's existing bridges, and their works are widely available.

This book is arranged geographically, starting in the southwest, proceeding north to Burlington and then to the southeast. Next is the central part of the state and, finally, the northern tier of counties, from west to east. The images represent only a sampling of Vermont's beauty. We hope they will inspire people to preserve covered bridges everywhere, keeping them in authentic repair by means of the same honest and efficient 19th-century technology that brought them into existence in the first place.

—Joseph D. Conwill
P.O. Box 829
Rangeley, Maine 04970

One

SOUTHWEST

BENNINGTON AND
RUTLAND COUNTIES

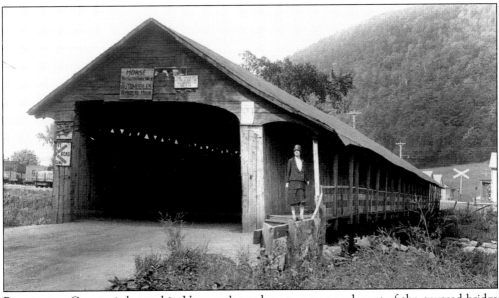

Bennington County is located in Vermont's southwest corner, and most of the covered bridge history involves the Hoosic River, the Walloomsac River, and the Batten Kill (not the Batten Kill River, which is redundant as *kill* is a local word of Dutch origin and means "river"). These streams flow westward toward the Hudson River, and there is much related covered bridge history over the state line in Washington County, New York. The southeastern part of the county is drained by the Deerfield River, which flows south into Massachusetts. Most of Rutland County's waters eventually reach Lake Champlain. Clarendon, just south of Rutland, was home to Vermont's best-known covered bridge builder, Nichols Montgomery Powers, several of whose bridges still serve traffic in the region. North Pownal Bridge, shown here, crossed the Hoosic River in Vermont's southwest corner. It is thought to have been built in the 1830s by Noel Barber, who also built a covered bridge at nearby Pownal. After serving for over a century, it was lost in the hurricane of 1938. (Richard Sanders Allen, c. 1937.)

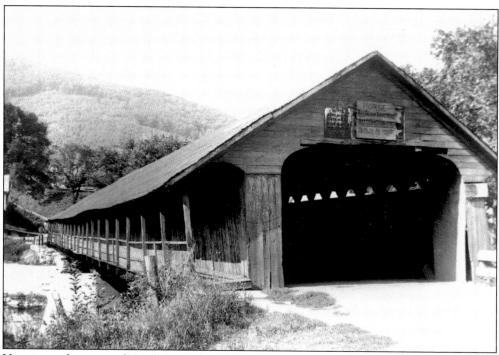

Here is another view of North Pownal Bridge. The river name is the Hoosic River, the village over the state line in New York is Hoosick, and the mountain with its famous railroad tunnel in western Massachusetts is Hoosac. (Richard Sanders Allen.)

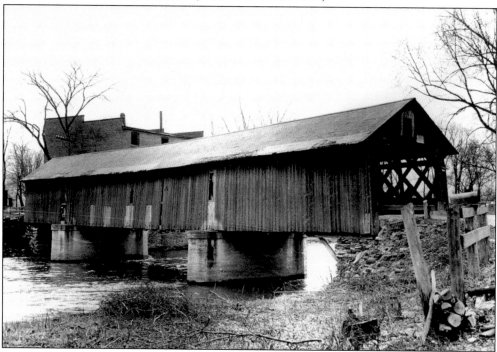

Pownal Bridge is thought to have been another Noel Barber product, built in 1834 or slightly afterward. It was torn down in 1949. (Henry A. Gibson, April 25, 1943.)

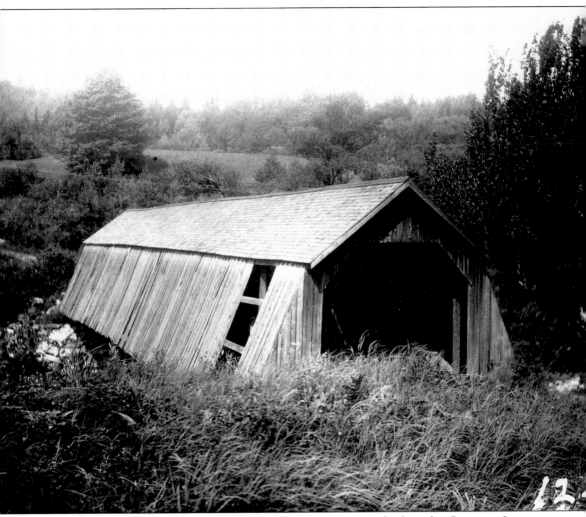

Upper Bridge in Searsburg crossed the Deerfield River on a remote back road to Somerset. It was removed for the construction of Searsburg Reservoir in 1915. The radically flared siding style was common in southern Oregon but very unusual in Vermont. It may have protected flying buttresses, or it may have been intended simply to direct rain runoff far from the critical lower chords of the truss. (Richard Sanders Allen collection.)

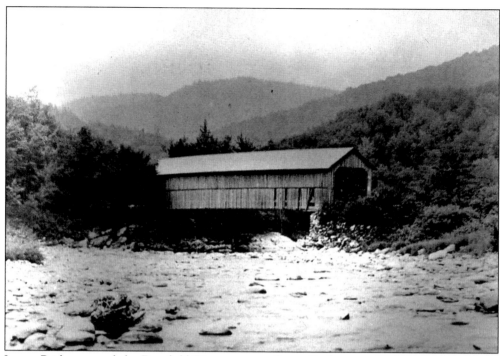

Lower Bridge crossed the Deerfield River on state Route 9, about two miles southeast of the village of Searsburg. (Oscar Lane notebooks.)

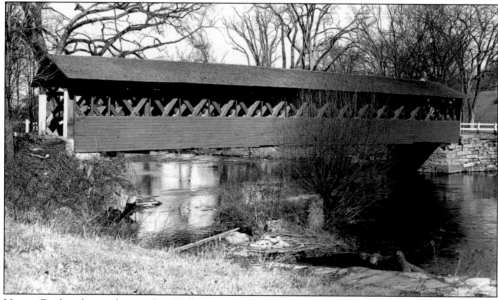

Henry Bridge, located over the Walloomsac River near North Bennington, was built *c.* 1840. It was torn down in 1989 and replaced with a replica built in the same style but with all new timber. (Henry A. Gibson, April 11, 1943.)

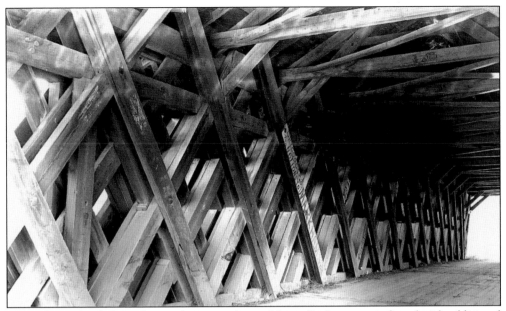

Due to heavy loads from the nearby iron industry, Henry Bridge was reinforced with additional truss work not long after it was built. The additions were poorly designed and were removed during repairs in 1952. (Henry A. Gibson, April 11, 1943.)

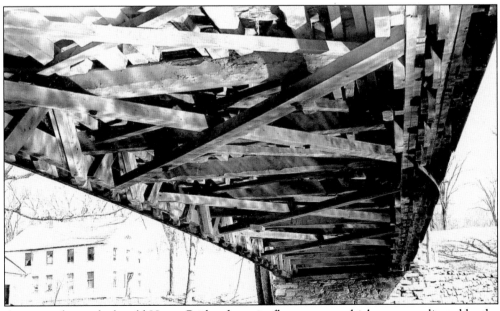

A view underneath the old Henry Bridge shows its floor system, which was complicated by the additional truss work. (Henry A. Gibson, April 11, 1943.)

West Arlington's 1852 vintage covered bridge still carries travelers over the Batten Kill near the former home of artist Norman Rockwell. (Henry A. Gibson, August 29, 1943.)

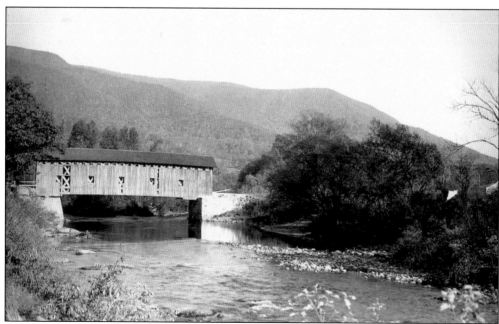

West Arlington's covered bridge has been painted red for about a half-century, and most people have forgotten that it was once unpainted. (Richard Sanders Allen collection.)

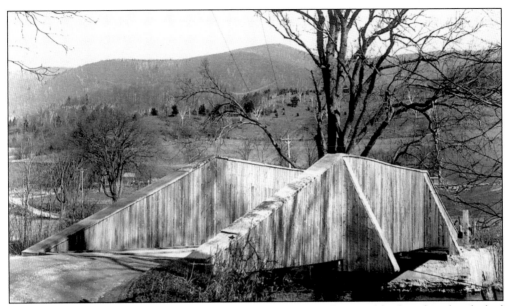

Vermont's boxed pony trusses were close historical relatives of covered bridges, but they lacked the romantic appeal of the other bridges, and none are left today. Benedict's Crossing spanned the Batten Kill between Arlington and West Arlington. An interesting non-covered, polygonal timber arch bridge now serves the site. (Richard Sanders Allen, November 9, 1941.)

McCauley Bridge crossed the Roaring Branch of the Batten Kill about one mile north of the village of Arlington. It was built in 1856 and lost in the great flood of 1927. The rustic-looking road later became U.S. Route 7. Today, it is known as the Historic Route 7A. (Oscar Lane notebooks.)

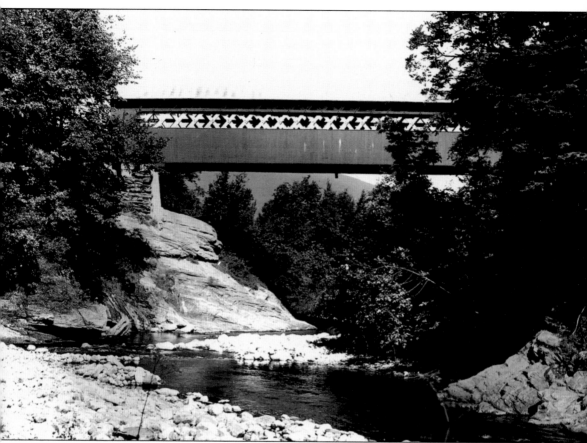

Chiselville Bridge is located near East Arlington but is over the town line in Sunderland. Today, the side view of the bridge is much less magnificent than this one, as the structure is now propped from below by concrete pilings. (Henry A. Gibson, August 29, 1943.)

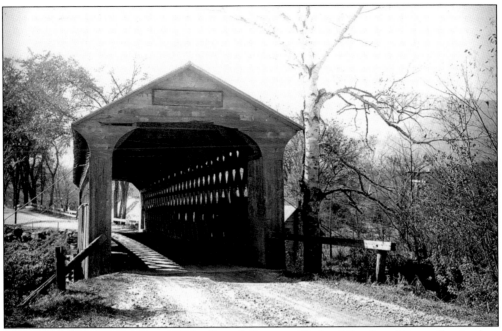

Chiselville Bridge was built in 1870 by Daniel Oatman. (Richard Sanders Allen collection.)

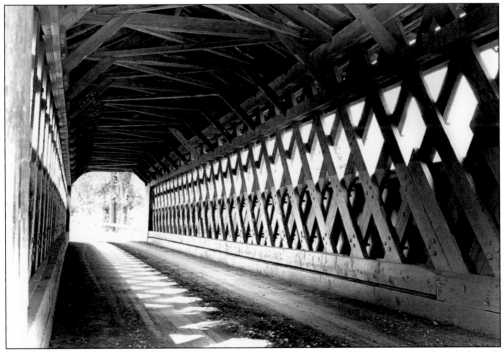

An interior view of Chiselville Bridge shows the lattice truss. In 1971, an overweight sand truck caused severe damage, which is why the bridge is now supported from below. (Henry A. Gibson, August 29, 1943.)

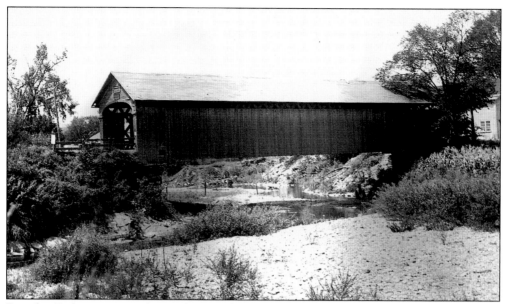

Foundry Bridge was one of several covered bridges spanning the Poultney River in Poultney, an important slate-quarrying region. Built in 1875, it served state Route 30 and sported a slate roof, as did other covered bridges and even barns in Rutland County. The bridge was removed in 1938. (Raymond Brainerd, August 13, 1938.)

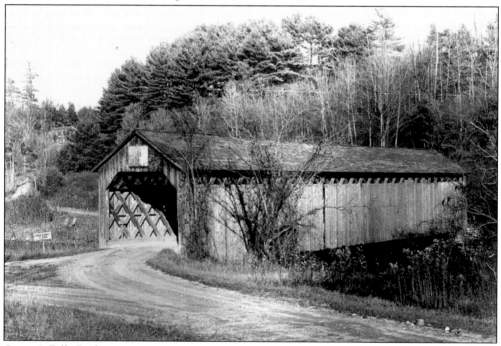

Carver's Falls Bridge was an interstate structure over the Poultney River. The eastern end was in Vermont, straddling the Fair Haven-West Haven town line, and the western end was in Washington County, New York. Threatened by an ice jam, the bridge was intentionally burned on March 31, 1940, so that it would not cause damage to structures downstream. (Richard Sanders Allen collection.)

Carver's Falls Bridge offered a convenient, protected home for rural mailboxes. The woman who appears to be checking the mail is in fact the photographer's wife, Barbara Brainerd. Viewing this photograph many years later, she said, "Oh yes! That was in the days when people wore hats!" (Raymond Brainerd, August 13, 1938.)

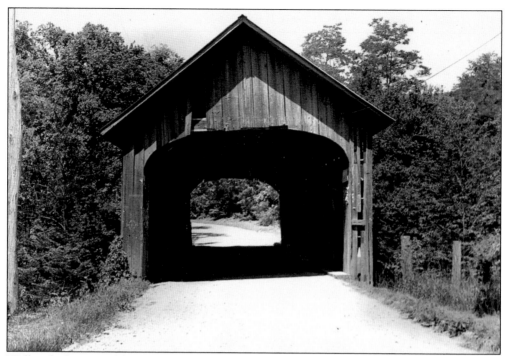

Wallingford's covered bridge over Otter Creek served state Route 140, which was then a quiet side road. Nichols M. Powers built it in 1874, and a streamside ledge outcrop served as most of the west abutment. The bridge was reputedly haunted by the ghost of a man who committed suicide inside it. A replacement was built in 1949. (Raymond Brainerd, July 4, 1939.)

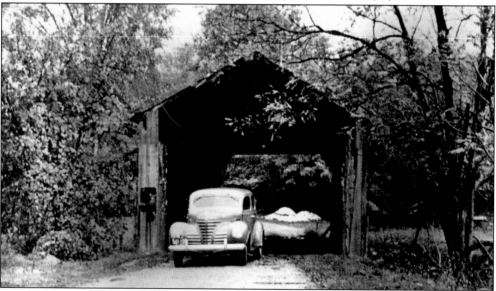

Marble Mill Bridge was located just north of Clarendon Springs, and like several other area covered bridges, it had marble abutments. Rutland County has extensive marble deposits, and the beautiful stone has even been used here for village sidewalks. The covered bridge carried heavy wagonloads of marble for many years before finally collapsing during a storm in August 1941. (Richard Sanders Allen collection.)

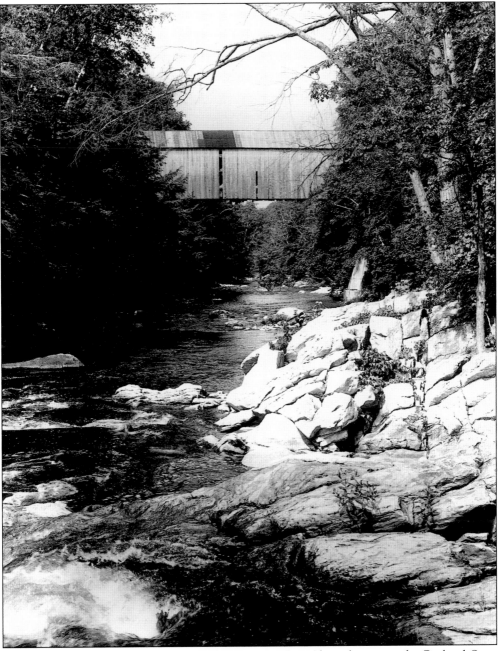

Kingsley Bridge stands high over the Mill River at East Clarendon, near the Rutland State Airport. Timothy K. Horton built the bridge in 1836, and it was probably rebuilt in 1870. It remains a picturesque site, although much of the old truss work was modified or discarded during repairs in the mid-1980s. (Herbert Richter, June 20, 1959.)

Brown Bridge still carries traffic over Cold River at a beautiful site in Shrewsbury, but it is difficult to photograph because it is surrounded by forest. In 2002, it was recorded for the Library of Congress by a team of architects and engineers from the Historic American Engineering Record. (Henry A. Gibson, October 6, 1948.)

Brown Bridge dates from 1880 and was the last project of famed builder Nichols M. Powers, from nearby Clarendon. Powers used a large streamside boulder for an abutment. (Henry A. Gibson, October 6, 1948.)

Billings Bridge was a well-known Rutland landmark of years gone by, crossing the Otter Creek at the south end of Park Street. The portal opening was sawed off to a higher point in later years, and trees eventually surrounded the bridge. It fell victim to arson in 1952, after which the last few hundred feet of Park Street were abandoned. However, an old rusty load-limit sign remained as a poignant reminder for at least another 20 years. (Photograph likely by Brehmer Studio; author's collection.)

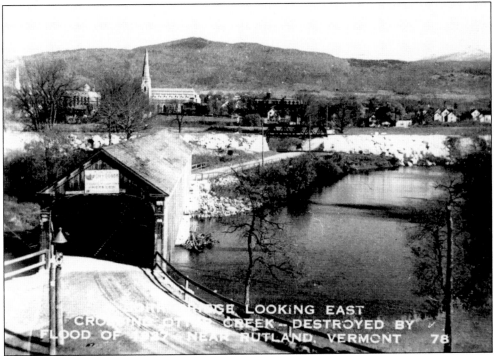

Dorr Bridge was another famous Rutland landmark. It crossed Otter Creek at the end of River Street on the edge of Rutland city. Built in 1871–1872 by Evelyn Pierpoint, it was lost in the flood of 1927. (Author's collection.)

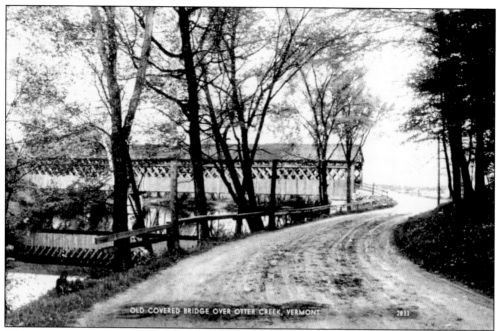

This is another view of Rutland's Dorr Bridge. Photographs are still common, even though the bridge has been gone for many years. However, they are often misidentified and have turned up as far away as Maine. (Author's collection.)

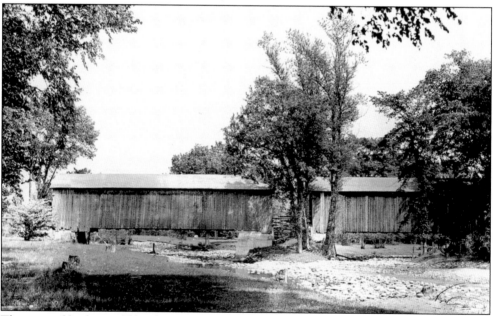

The covered bridge world has known many sets of twins, but the Twin Bridges over East Creek, north of Rutland, were among the closest together. Nichols M. Powers built one in 1849, only to have it left high and dry in a flood that changed the creek's channel. He returned in 1850 to build the second. The twins lasted nearly a century before being lost in a flash flood in 1947, when a dam upstream gave way. One twin was salvaged for use as a town shed nearby, and today, there is talk of restoring it as a covered bridge. (Richard Sanders Allen.)

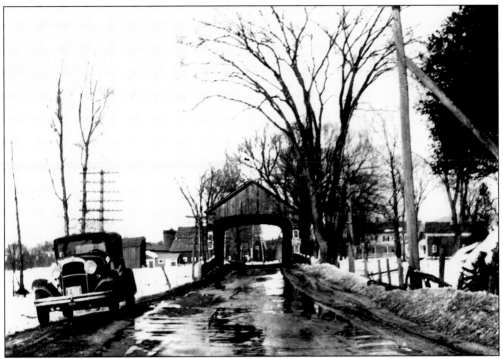

Lester Bridge crossed East Creek on U.S. Route 7 about a mile north of the Rutland city limits. It was constructed by Nichols M. Powers c. 1845. Milo Lester's farm is visible in the background. The bridge was taken down for a road-widening project in 1931. (Photograph by Larry Russell; Christine Ellsworth collection.)

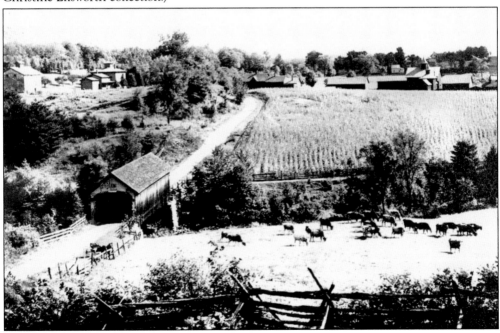

Old '76 Bridge crossed East Creek near the Rutland Country Club and was another casualty of the 1947 flash flood. (Photograph likely by Brehmer Studio.)

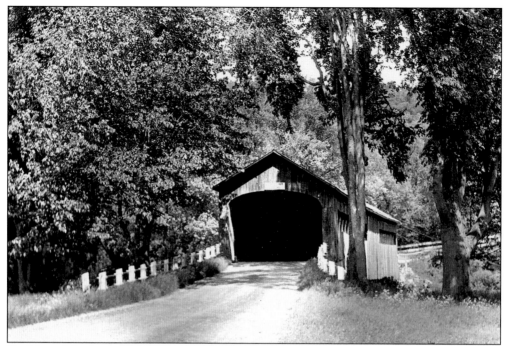

Doubleroad Bridge spanned Otter Creek about halfway between Proctor and Center Rutland. It was a Town lattice truss, but it also had a segmented timber arch attached, which is unusual in this truss form. Damaged in the 1927 flood, it was patched up and used until 1950. (Richard Sanders Allen collection.)

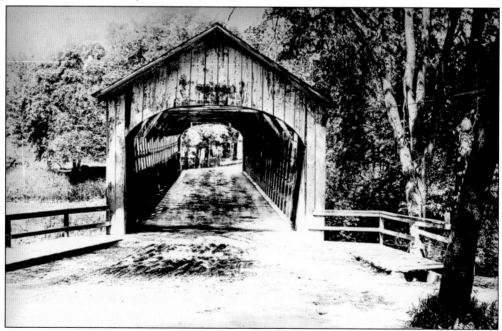

The covered bridge over Otter Creek at downtown Proctor was built in 1841 by Lewis Wolcott of Pittsford. It was removed in 1914–1915, when the Marble Memorial Bridge was built. (Stephen H. Conwill collection.)

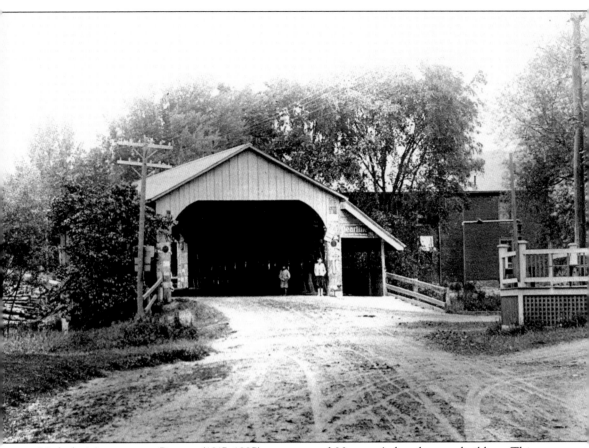

Nichols Montgomery Powers (1817–1897) was one of Vermont's best-known builders. This bridge at Pittsford Mills was his first, and he was still legally a minor when he built it in 1837. It lasted until 1931 and was replaced, not because it was weak, but because U.S. Route 7 took over the road it served and it was no longer wide enough for the increased traffic. During construction of its replacement, a 20-ton steamroller used the old covered bridge. Powers was involved in other aspects of industrial work such as railroading and quarrying; he also had a farm in Clarendon and a cheese factory. His first name has been misunderstood as Nicholas but it was really Nichols. (Richard Sanders Allen collection.)

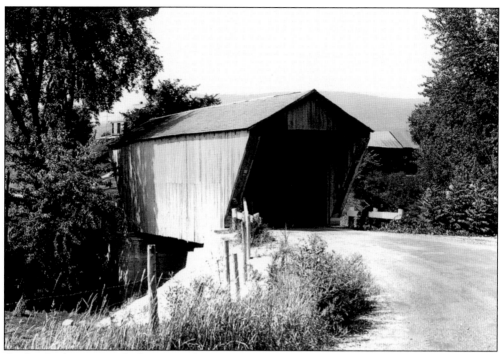

Cooley Bridge in Pittsford was another product of Nichols M. Powers and was built in 1849. (Herbert Richter, August 22, 1955.)

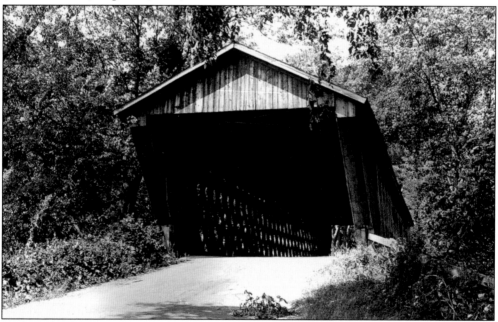

Gorham Bridge spans Otter Creek on the Pittsford-Proctor town line. Originally built in 1841–1842, it underwent extensive repairs in 1956 and again in 2003. The lower chords (bottom horizontal members of the truss) showed much wear, and they were replaced with modern prefabricated glue-laminated members in the 2003 work. (Herbert Richter, August 22, 1955.)

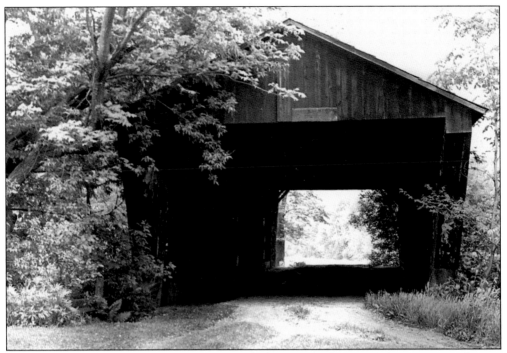

Mead Bridge also crossed Otter Creek in Pittsford. It was built in 1840, but at some unknown date, the road it served was discontinued and the bridge led only to some fields. The kindly Will Davenport lived next to the bridge, and visitors who had the time could tour his garden, which included plants mentioned in the Bible. Mead Bridge fell victim to arson in 1971, and there is no bridge here today. (Raymond Brainerd, May 31, 1946.)

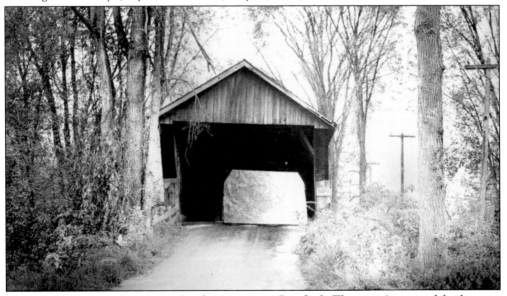

Depot Bridge is another Otter Creek crossing in Pittsford. The town's covered bridges are similar in appearance, and photographs are often confused. All of the bridges have overhung portals, but those on Depot Bridge begin higher up than do those on the others in town. (Author's collection.)

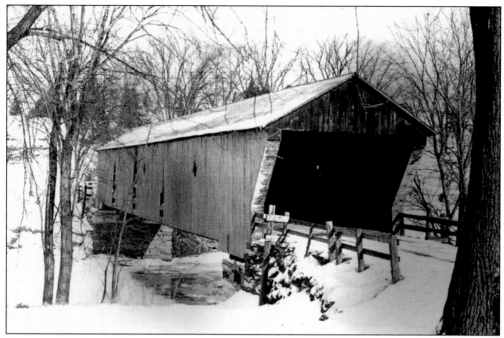

Hammond Bridge is the northernmost covered bridge in Pittsford, spanning Otter Creek near the hamlet of Florence. It still stands but is bypassed and no longer carries traffic. (Richard Sanders Allen collection.)

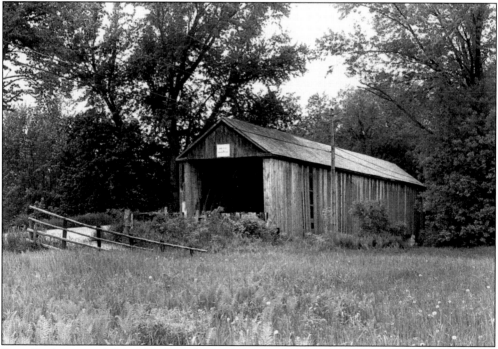

Dean Bridge crossed Otter Creek in the southern part of Brandon on what was once known as Clay Street—the road name has been changed in recent years. Of uncertain age, the bridge fell victim to arson in 1989. (Joseph D. Conwill, June 3, 1983.)

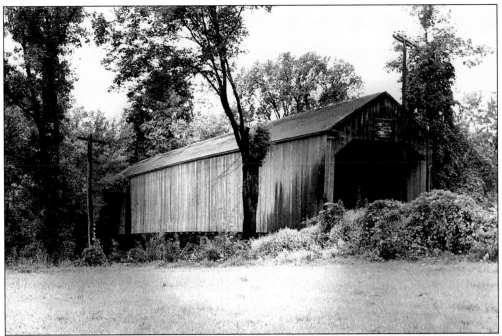

The next bridge downstream that spanned Otter Creek was Sanderson Bridge, also in Brandon, on what was then known as Pearl Street. An entirely new covered bridge was built here in 2003, and the 1838 bridge in this photograph became only a memory. (Raymond Brainerd, October 1, 1946.)

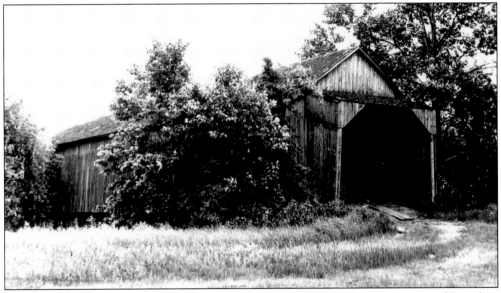

Privately owned, Conant Farm Bridge spanned Otter Creek at a large farm west of Brandon. The odd porchlike appendage prevented wind-driven rain from wetting the ends of the truss work and was probably a later addition. The builder is unknown, although the widely spaced Town lattice truss work resembled that of the existing Salisbury Station Bridge, located some 10 miles downstream. The Conant Farm Bridge collapsed from neglect in 1949. (Author's collection.)

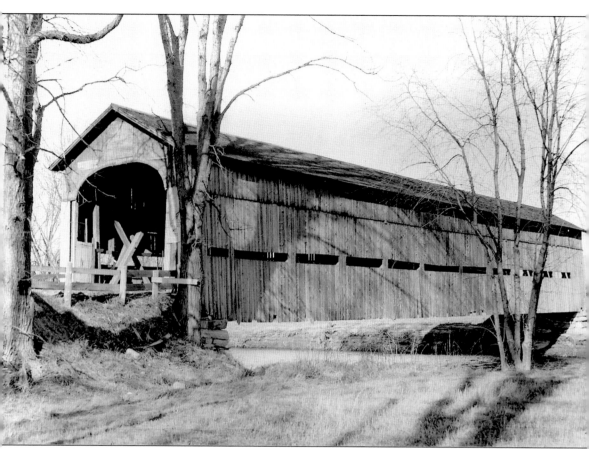

Miller Bridge in Sudbury was built in 1866 by James E. Bagley and served state Route F-10 near the Brandon town line. It was a Howe truss, a type common on railroads but only occasionally used for highway bridges in Vermont. The road was relocated in 1951–1952, and the covered bridge was removed. Highways numbered with an *F* prefix terminated at Lake Champlain ferries. All but one have since been renumbered, and F-10 is now state Route 73. (Henry A. Gibson, April 17, 1948.)

Two

WEST
ADDISON AND
CHITTENDEN COUNTIES

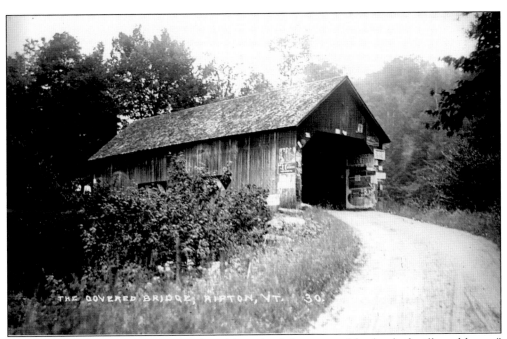

THE COVERED BRIDGE, RIPTON, VT. 30.

Addison County is Vermont's agricultural heartland, known as "the land of milk and honey" from two important local products. Through it flows Otter Creek, Vermont's longest river, which reaches Lake Champlain at Ferrisburgh. Chittenden County, by contrast, is Vermont's most urban region. Both the Winooski River and the Lamoille River enter Lake Champlain here to either side of Malletts Bay. The covered bridges show a transition from the Town lattice truss, popular farther south in the state, to the Burr truss that is common in the north. The mountainous eastern edge of Addison County had several covered bridges in Lincoln and in Ripton. This one was located in Ripton, but little is known of its history. (Richard Sanders Allen collection.)

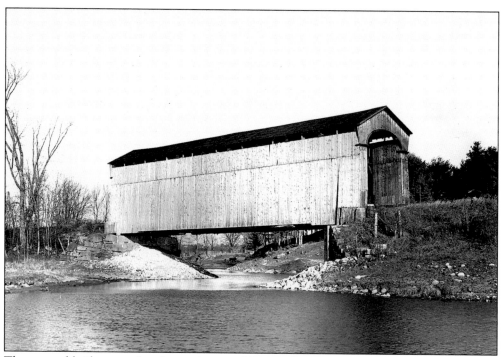

The covered bridge over the pleasantly named Lemon Fair River at East Shoreham served the Addison Branch of the Rutland Railroad, which once crossed Lake Champlain to Ticonderoga, New York. It is believed to date from 1897 but shows obvious signs of later reinforcement. Rail service was discontinued in 1951. (Henry A. Gibson, April 17, 1948.)

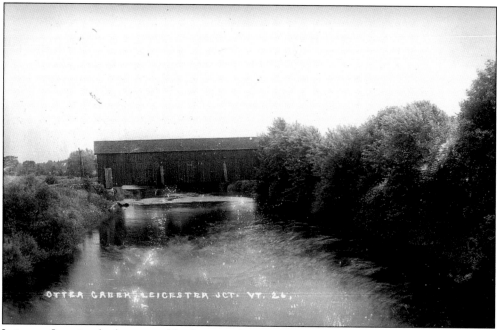

Leicester Junction had a covered bridge over Otter Creek, but little is known about its history. (Oscar Lane notebooks.)

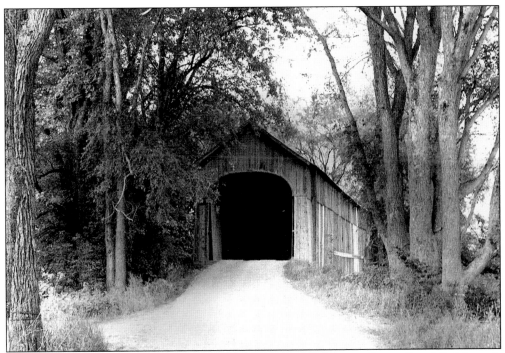

Salisbury Station Bridge was built in 1865 over Otter Creek between Cornwall and Salisbury. It was originally a one-span bridge, but a center pier was added in 1969. At one time it was painted yellow with red trim. (Herbert Richter, August 11, 1956.)

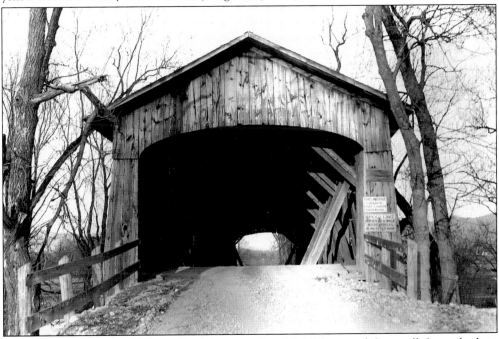

Three-Mile Bridge crossed Otter Creek between East Middlebury and Cornwall. It was built in 1836, but the buttresslike interior sway braces were a much later addition. It fell victim to arson in 1952. (Henry A. Gibson, April 17, 1948.)

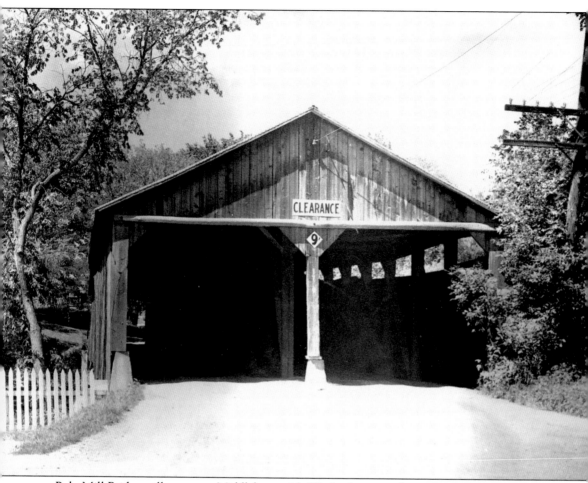

Pulp Mill Bridge still connects Middlebury with Weybridge, over Otter Creek. It is one of only six double-barreled covered bridges in America; that is, it has two lanes for traffic, divided by a center truss. Such bridges were more common in the early period of covered bridge construction, and this was once thought to be an 1820s bridge. Careful research by bridge wright Jan Lewandoski and by historian Lola Bennett has shown that the existing structure is an 1853–1854 replacement. (Raymond Brainerd, October 1, 1946.)

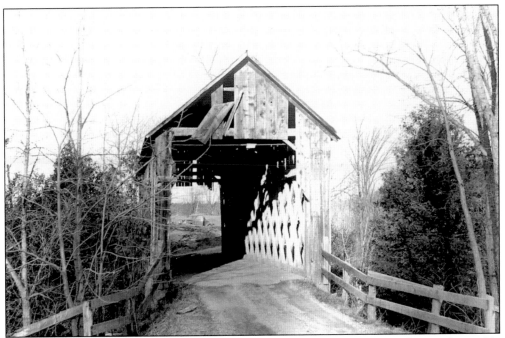

Halpin Bridge still serves a large farm north of Middlebury in an area once known for marble quarrying. It is of uncertain age; an 1824 date is often cited but is most unlikely. (Henry A. Gibson, April 18, 1948.)

The tall, impressive, dry-laid stone abutments of Halpin Bridge were replaced with concrete during recent repairs. (Richard Sanders Allen, October 5, 1941.)

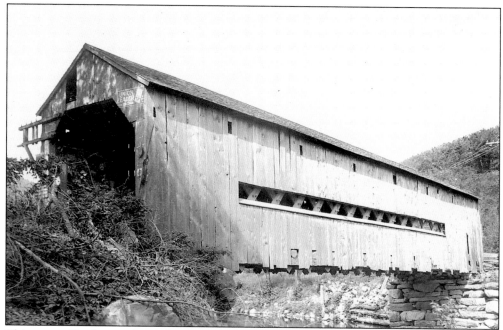

This covered bridge was located in Bristol, about one mile east of the village. (Richard Sanders Allen collection.)

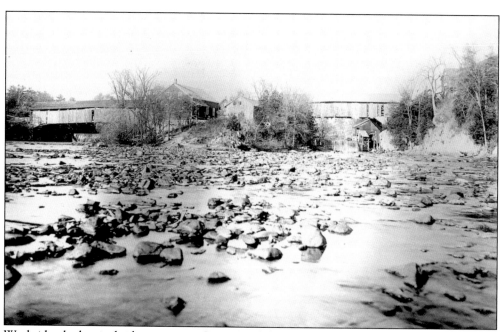

Weybridge had twin bridges crossing Otter Creek by way of a small island. (Richard Sanders Allen collection.)

By a quirk of geography, Reef Bridge, or Chalker Bridge, was on the New Haven-Weybridge town line near the limits of Addison and Waltham. All four towns contributed to its construction in 1832. A road relocation set the bridge's 1934 replacement entirely in New Haven, at which point the covered bridge reverted to a local farmer who later tore it down because he needed the lumber to build a new barn. (Richard Sanders Allen collection.)

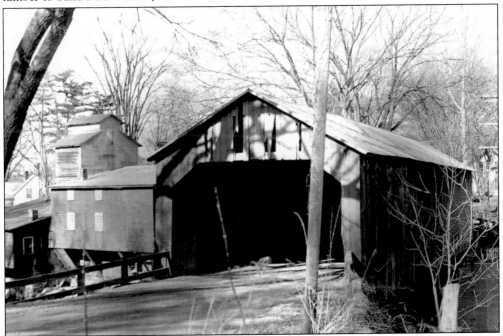

North Ferrisburgh's covered bridge still exists but not at this original location. Threatened with replacement, it was moved to the nearby Spade Farm in 1958. (Henry A. Gibson, April 18, 1948.)

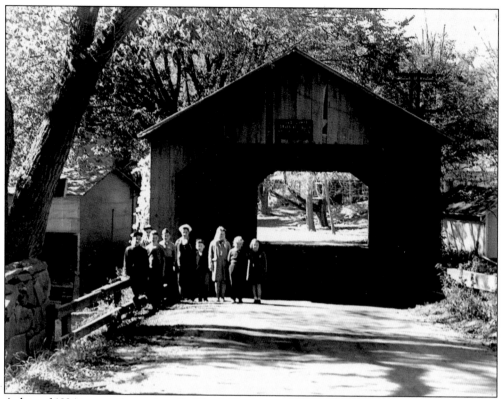

A date of 1824 is sometimes given for North Ferrisburgh's bridge. However, that date is obviously too early, and more research is needed. (Raymond Brainerd, October 3, 1946.)

This little covered bridge is often described as having been in Vergennes, but in fact, it was in Ferrisburgh, over Little Otter Creek on the Monkton Road. It was replaced in the early 1950s. (Raymond Brainerd, October 2, 1951.)

Lake Shore Bridge still spans Holmes Creek almost on Lake Champlain's shore, which can just be seen through the brush at the right. It was originally a simple tied-arch bridge, that is, it had an arch that is attached to a horizontal lower chord instead of footing on the abutments. The kingpost bracing is a later addition. (Author's collection.)

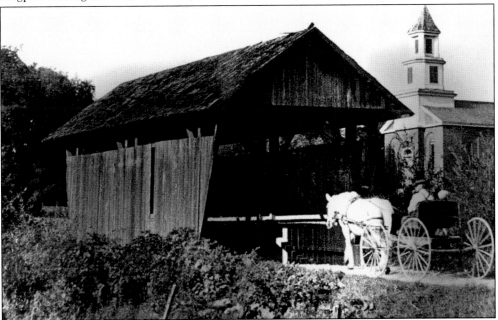

Davies Bridge in Hinesburg had diminutive truss work, and it is surprising that it was ever covered. (Photograph by James R. Parker; Richard Sanders Allen collection.)

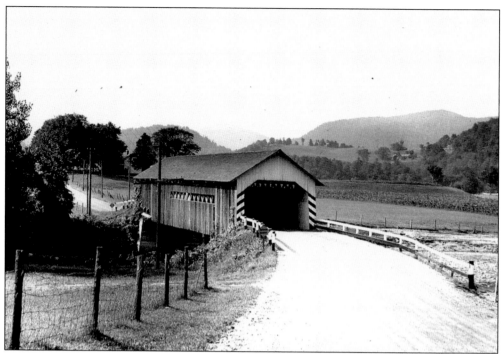

Towers Bridge spanned the Huntington River at a picturesque site in the southern part of Richmond. (Richard Sanders Allen, July 29, 1940.)

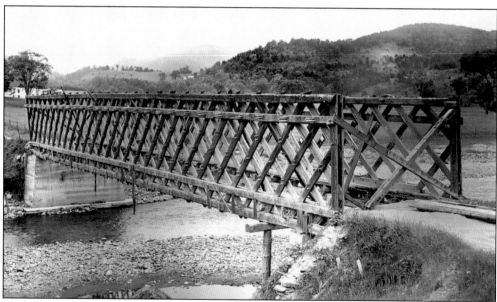

This image of the removal of Towers Bridge shows the Town lattice truss work clearly. It is hard to figure out what is going on, but it appears that the workmen punched out most of the treenails (wooden pegs) and then realized that the bridge would collapse with them on it if they kept it up. (Henry A. Gibson, June 15, 1948.)

Checkered House Bridge, located on U.S. Route 2 in Richmond, was one of several double-barreled covered bridges spanning the Winooski River between Burlington and Montpelier. The bridge survived the great 1927 flood, but the waters cut around both abutments, and it was replaced in 1929. Interstate 89 crosses the Winooski River at nearly the same site today. (Photograph likely by Burnham of Burlington; Richard Sanders Allen collection.)

Heineberg Bridge (often misspelled Heineburg) connected Burlington with Colchester near the mouth of the Winooski River. Built for $1,280 in 1860 by Henry R. Campbell, who was known mainly for covered railroad bridges, it survived the great 1927 flood but was replaced shortly afterward. (Author's collection.)

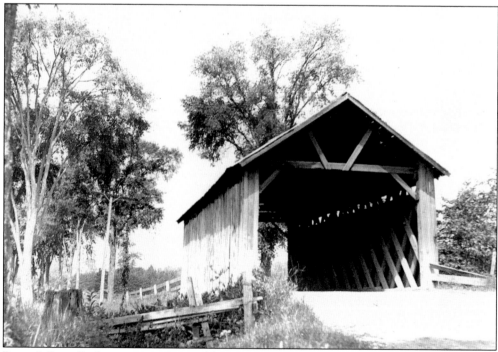

Brown's River Bridge was one of several long gone covered bridges in the town of Essex. It was demolished soon after this photograph was taken. There was another Brown's River Bridge located in Fairfax. (Richard Sanders Allen, July 27, 1940.)

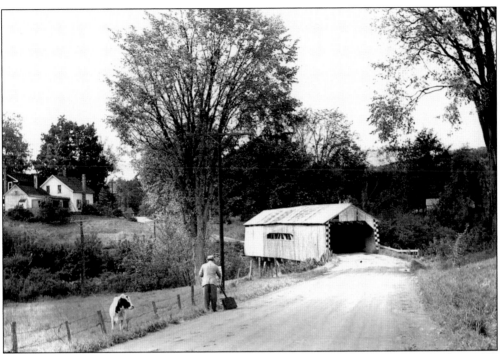

Yet another Brown's River Bridge served traffic just outside Westford's village center from 1838 to 1965. Here, an artist captures the rural scene. (Raymond Brainerd, September 28, 1951.)

This looks like the end for Brown's River Bridge in Westford. In fact, the covered bridge was bypassed in 1965 but left standing. It has recently been restored after heroic fund-raising efforts by the residents of this small town. (Raymond Brainerd, October 16, 1965.)

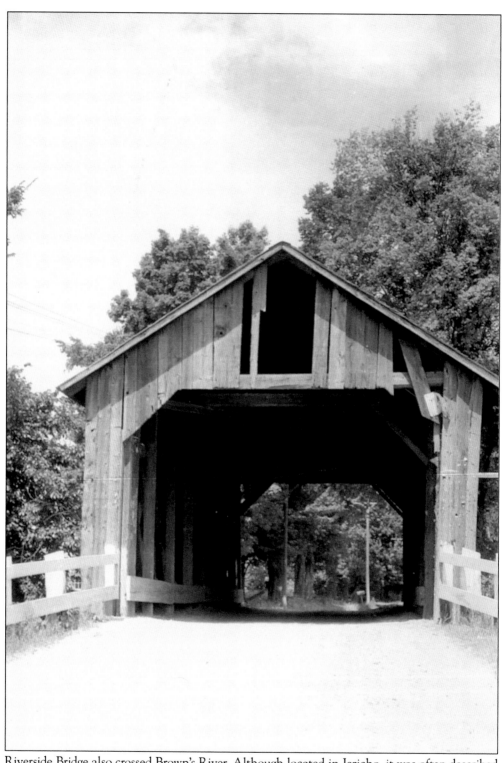

Riverside Bridge also crossed Brown's River. Although located in Jericho, it was often described as being in Underhill. (Richard Sanders Allen collection.)

Three

SOUTHEAST CORNER
WINDHAM COUNTY

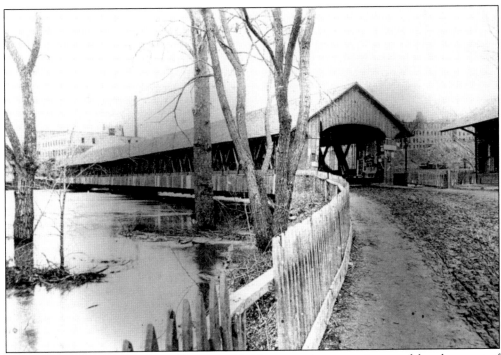

Windham County had at least 70 covered bridges over its many rivers and brooks, most of which flow into the Connecticut River. Sanford Granger and Caleb Lamson were noted area builders and used the Town lattice truss. Queenpost or kingpost trusses were common in the county's smaller spans. Brattleboro Toll Bridge, shown here, crossed the main channel of the Connecticut River from Vermont to Barrett's Island. A smaller bridge over the side channel was located entirely in New Hampshire. The main bridge was a Howe truss built in 1870 to replace an earlier covered bridge lost in the great 1869 flood. The new bridge served until 1903. (Richard Sanders Allen collection.)

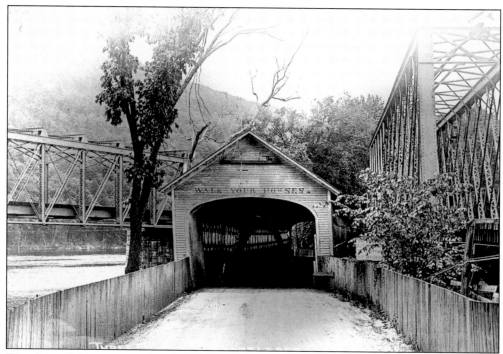

West River Bridge was another famous Brattleboro landmark of years gone by. Built in 1862, it was one of seven known bridges having a lattice truss made of notched squared timbers instead of flat planks. It was wedged tightly between two railroad bridges and, until 1927, served the road that became U.S. Route 5. (Richard Sanders Allen collection.)

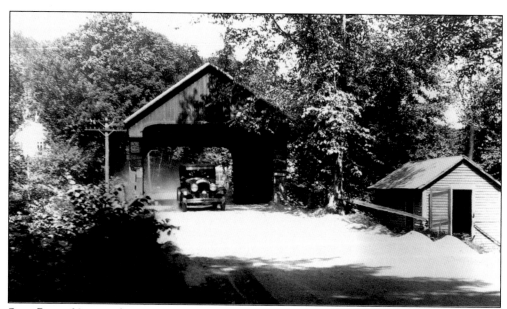

State Route 30 crossed numerous covered bridges including Taft Bridge, near West Dummerston. When replaced in 1951, it was moved to Old Sturbridge Village in Massachusetts, where it lives out a happy retirement. (Photograph by Basil Kievit; Richard Sanders Allen collection.)

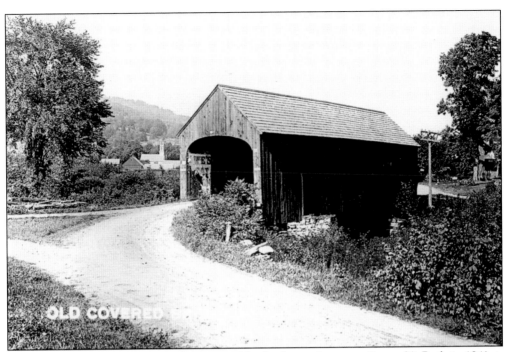

Newfane Village Bridge was another covered bridge located on state Route 30. Built in 1841, it was removed in 1945. The original arched portals were later squared off at a greater height to admit taller trucks. (Richard Sanders Allen collection.)

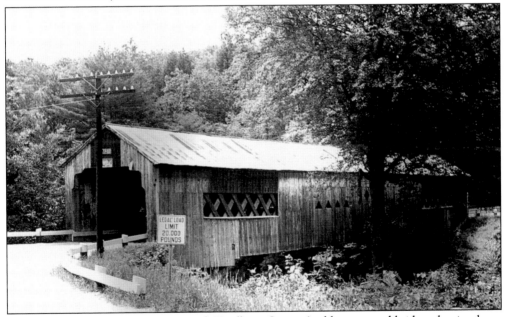

Branch Bridge in Newfane was one of Windham County's oldest covered bridges, having been built in 1837. The portal is thought to have been arched originally, but this view shows it squared off for modern traffic, incidentally revealing the ship's knees for sway bracing, which were probably a later modification. Bypassed by a new bridge in 1938, it was torn down in 1940. (Raymond Brainerd, July 4, 1937.)

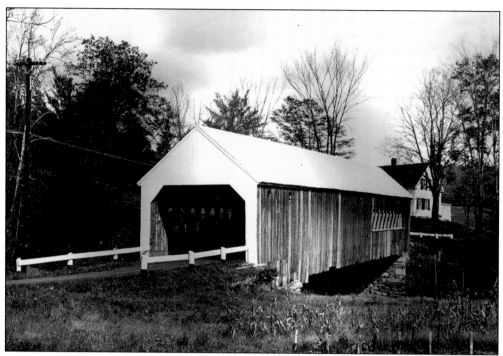

Williamsville Bridge, of uncertain age, was another of Newfane's covered bridges. It still stands but will probably soon be replaced, having been badly damaged by well-intentioned but ill-planned repairs c. 1980. (Raymond Brainerd, October 11, 1936.)

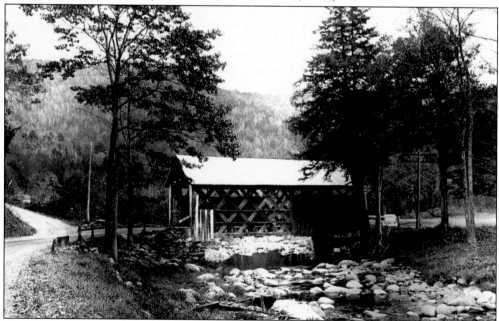

Brookside Bridge spanned Rock River between South Newfane and East Dover. Its Town lattice truss was lighter than usual and lacked the secondary chords often found in this design. It was damaged by the 1936 flood and completely lost in the flood of 1938. (Raymond Brainerd, October 11, 1936.)

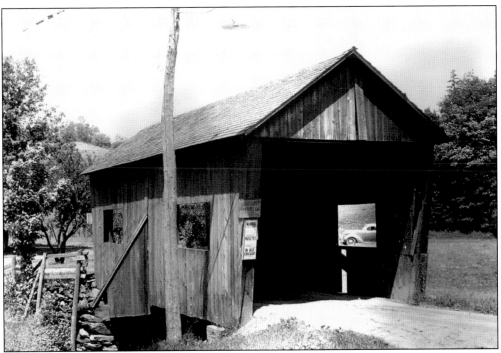

West Dover's little covered bridge, located over the North Branch of the Deerfield River, was built by John B. Davis in 1882 and was another casualty of the 1938 flood. (Richard Sanders Allen, 1938.)

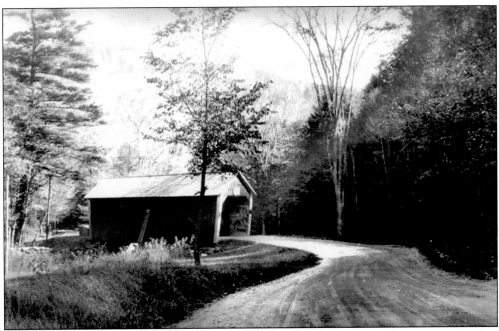

Center Bridge in Wardsboro was also a victim of the 1938 flood. (Richard Sanders Allen collection.)

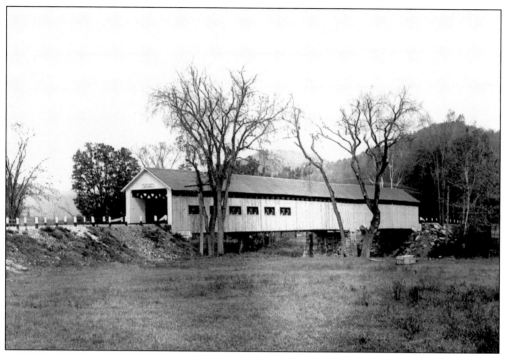

Holland Bridge, which spanned the West River in Townshend, was a major landmark on state Route 30. Many travelers remembered it because it was painted green, an unusual color for covered bridges. Built in 1875, it survived the ever-increasing traffic until 1952. (Raymond Brainerd, October 11, 1936.)

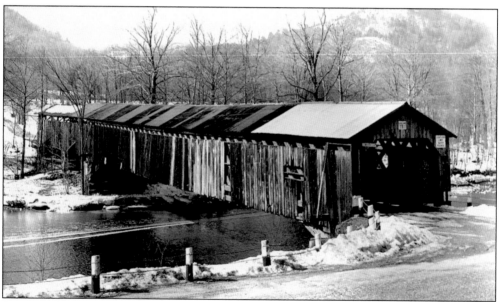

Scott Bridge crosses the West River in Townshend with one lengthy Town lattice span over the main channel, plus two short kingpost approaches over the flood plain. Since 1981, the main span has been propped in the middle by a new center pier. (Henry A. Gibson, February 19, 1949.)

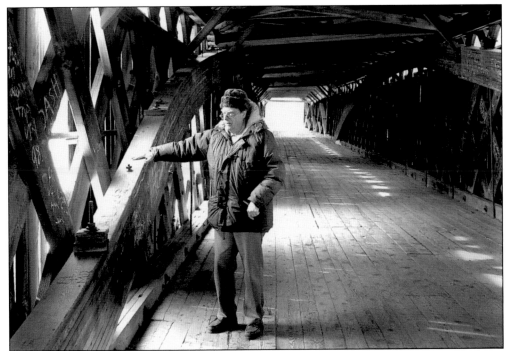

Years ago, laminated arches were added to reinforce Scott Bridge in Townshend, but as with most skilled work, there is a trick to it. Here, the arch leaves were inadequately fixed together, and uneven tightening of the hanger rods caused the arches to buckle. In this photograph, David W. Wright, president of the National Society for the Preservation of Covered Bridges, has a look at the nearly useless arches. If done properly, laminated arches are an excellent means of reinforcing a covered bridge in keeping with 19th-century technology. (Joseph D. Conwill, February 20, 2004.)

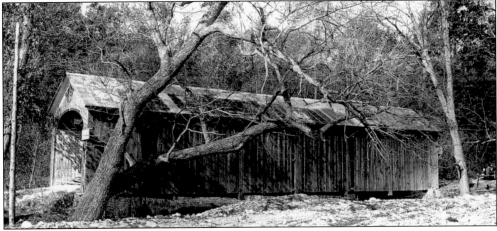

West Townshend Depot Bridge crossed an overflow gully leading from the nearby West River. It is said that during the 1938 flood, which was caused by a surprise hurricane, water under the bridge rose six feet in only eight minutes. The bridge was removed for a flood control project in 1959, but the timbers were stored and the bridge was rebuilt in Rockingham in 1967. Since the new site required a shorter bridge, the original queenpost truss was cut down to a kingpost. (Henry A. Gibson, October 9, 1938.)

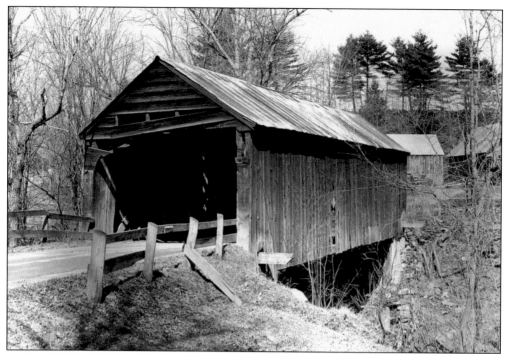

Lewis Bridge in Westminster was built in 1838 and was only 41 feet long. It was found to be too short to span floodwaters safely. Five years later famed builder Sanford Granger raised it and lengthened it to 65 feet. Thus it stood, looking like a real antique, until it was replaced in 1953. (Henry A. Gibson, April 10, 1948.)

The privately owned Basin Farm Bridge, located over the Saxtons River in Westminster, started out as a boxed pony truss but was later converted to a fully covered bridge c. 1938. Lack of maintenance caused its collapse in 1958. (Author's collection.)

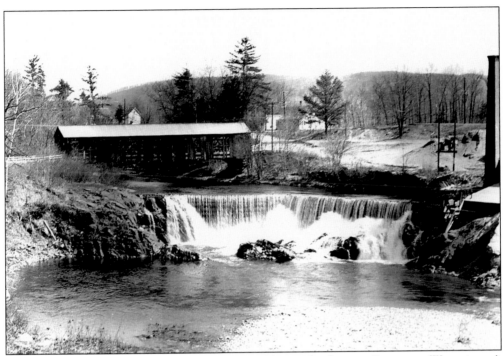

Gageville Bridge, built by Sanford Granger in 1835 over the Saxtons River, was Westminster's last covered bridge when it fell victim to arson in 1967. (Henry A. Gibson, April 10, 1948.)

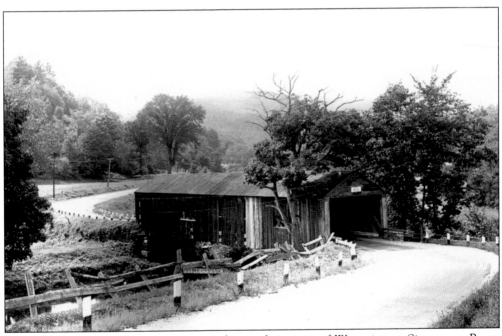

Sabin Bridge spanned Saxtons River in the northern part of Westminster. Since state Route 121 only loops through a small portion of town, the bridge served primarily residents of Rockingham and Grafton, who contributed to its cost. It was replaced in 1941 with a wider bridge on a straighter approach. (Raymond Brainerd, August 20, 1938.)

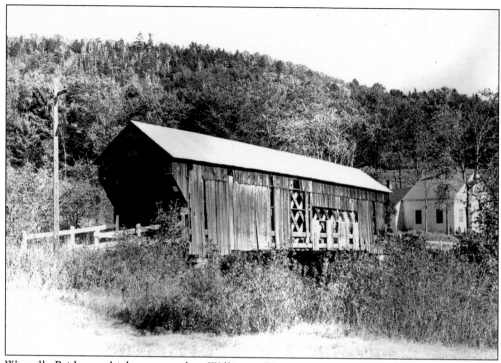

Worrall Bridge, which spans the Williams River, is one of Rockingham's existing covered bridges. It is in better repair today than at the time of this picture, but it is now difficult to photograph because of an automobile junk yard next-door. (Raymond Brainerd, October 4, 1945.)

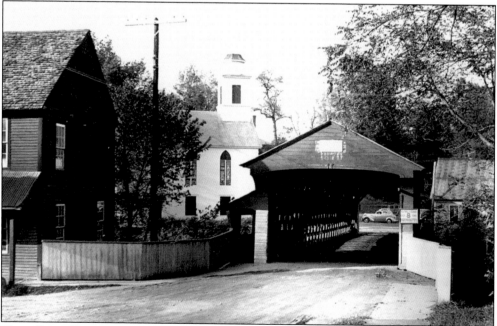

The village of Saxtons River in Rockingham had this lovely covered bridge until 1949. (Richard Sanders Allen.)

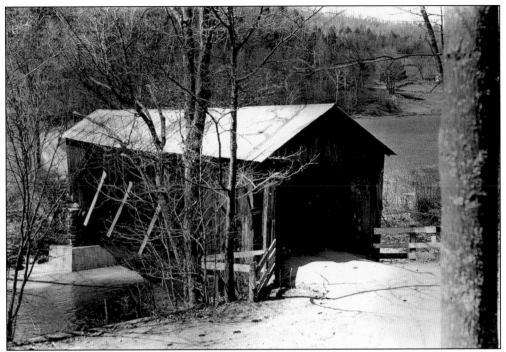

Jones Bridge was another old Rockingham covered bridge. Built in 1870, it spanned the Saxtons River on a small side road between Saxtons River and Cambridgeport. The roof collapsed in 1963, and the bridge was torn down the following year. (Henry A. Gibson, April 10, 1948.)

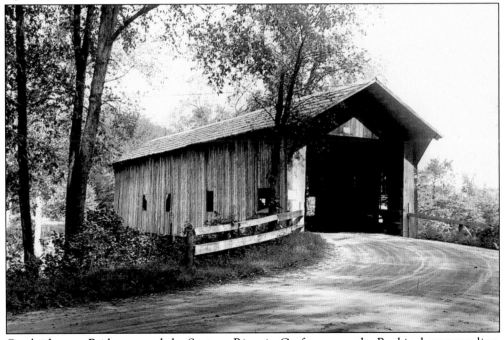

Cambridgeport Bridge crossed the Saxtons River in Grafton, near the Rockingham town line. It served state Route 121 until 1941. (Raymond Brainerd, August 20, 1938.)

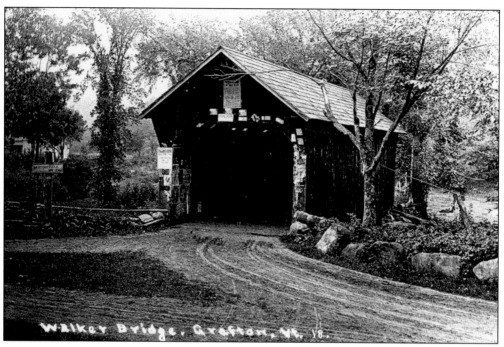

Walker Bridge was another Saxtons River crossing located in Grafton in days gone by. It was replaced in 1937. (Richard Sanders Allen collection.)

Kidder Bridge still stands on the southern edge of Grafton village. The district beyond was abandoned for several decades, and the bridge saw little traffic. With resettlement of the area in recent years, there was concern that the old bridge could not handle fire trucks. Huge glue-laminated beams were added in the mid-1990s. (Raymond Brainerd, August 20, 1938.)

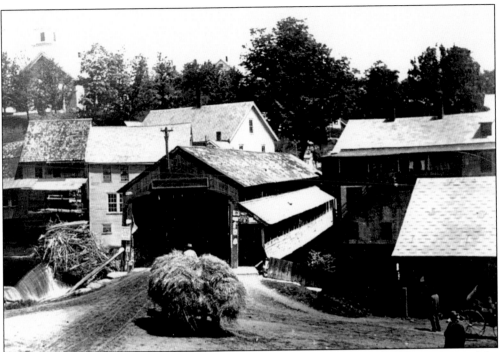

Writers in the early 20th century sometimes said that covered bridges had been designed for "a load of hay high and wide." This must have been a good practical standard, but there is no confirmation of it from earlier sources. Here, a man with a load of hay is about to enter the covered bridge across West River in South Londonderry, as onlookers at the lower right check to see if he makes it. (Richard Sanders Allen collection.)

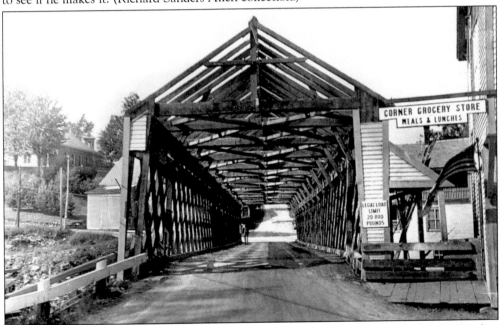

South Londonderry's covered bridge was removed in 1937. (Richard Sanders Allen collection.)

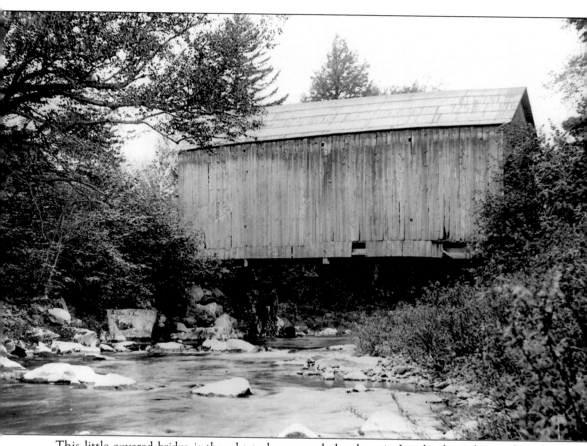

This little covered bridge is thought to have stood elsewhere in Londonderry, but nothing is known of its history. (Richard Sanders Allen collection.)

Four

SOUTHEAST
WINDSOR COUNTY

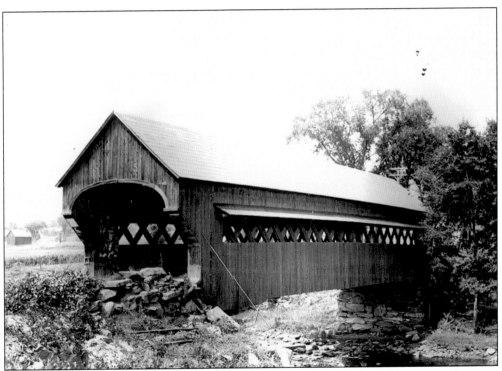

Windsor County was another stronghold of Town lattice truss bridge construction. Inventor Ithiel Town's partner, Isaac Damon, built an early bridge of this type in the area, the Cheshire Bridge over the Connecticut River in Springfield. Other truss types such as the Long and the Burr also appeared in the county, and some of the upland regions showed a preference for the multiple kingpost truss. James F. Tasker of Cornish, New Hampshire, was a prominent builder here. Windsor County had more than 100 covered bridges, including those over the Connecticut River. The last of several covered bridges in Chester was Mill Bridge, shown here. Located near North Chester, it was lost in the 1938 flood. (Raymond Brainerd, July 22, 1935.)

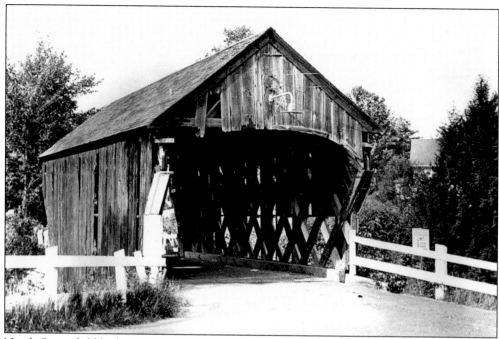

North Springfield had a pair of twin covered bridges just west of the village. One was replaced years ago, but this survivor, on Baltimore Road, hung on until being moved to a nearby park in 1970. (Richard Sanders Allen collection.)

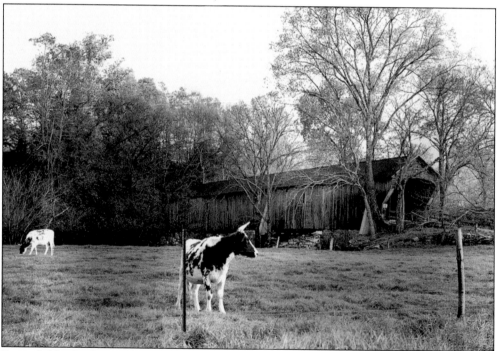

Butterfield's Bridge in Weathersfield was one of four covered bridges lost when the North Springfield dam impounded the Black River Valley in 1960. (Raymond Brainerd, October 9, 1945.)

This is another view of Butterfield's Bridge in Weathersfield. The overhung, arched-portal style was very popular in Windsor County. (Herbert Richter, August 12, 1956.)

Best's Bridge, which still exists, was one of five minuscule covered bridges in West Windsor built on a pure tied-arch plan, with no additional truss. (Raymond Brainerd, June 6, 1952.)

Brownsville Bridge is another of West Windsor's little pure tied-arch bridges. There is a similar structure near West Woodstock that has truss work under the arch because it has a much longer span. (Raymond Brainerd, June 6, 1952.)

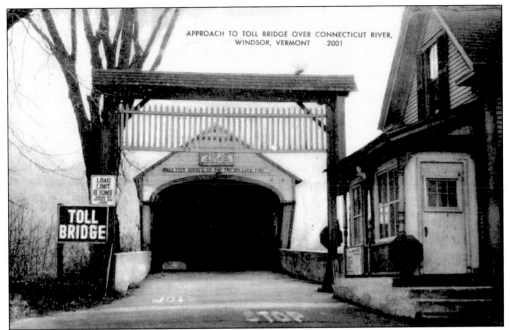

Cornish-Windsor Bridge, over the Connecticut River to New Hampshire, is said to be the longest covered bridge in the United States, at 460 feet, although there is a very close rival near Medora, Indiana. The tollgate came down in 1943. (Author's collection.)

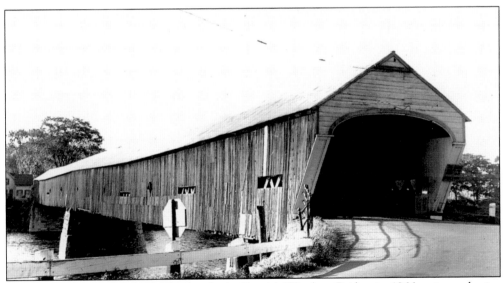

James F. Tasker and Bela J. Fletcher built Cornish-Windsor Bridge in 1866, using a lattice truss with squared notched timbers instead of the usual planks. The trusses were too shallow in height for the long span lengths, and the bridge sagged at an early date. In 1988, following sophisticated engineering work by David C. Fischetti, the lower chords of the bridge were removed and replaced with glue-laminated members, and the bridge now works well. Many preservationists criticized the removal of so much of the old truss work, pointing out that laminated arches could have done the job in keeping with historical technology. (Raymond Brainerd, October 4, 1945.)

Martin's Mill Bridge is in Martinsville, just south of Hartland, and is directly adjacent to Interstate 91 southbound. It is difficult to see because it is on a lower level and screened by trees. (C. Ernest Walker.)

Readily visible from Interstate 91 northbound at North Hartland is Willard's Bridge, over the Ottauquechee River. The bridge can also be seen from an Amtrak train. A nearby twin covered bridge was replaced by a concrete bridge years ago, but the concrete one gave way in 2001 to a new covered bridge built by Jan Lewandoski. Thus, once again, there are twin bridges here. (Henry A. Gibson, June 12, 1948.)

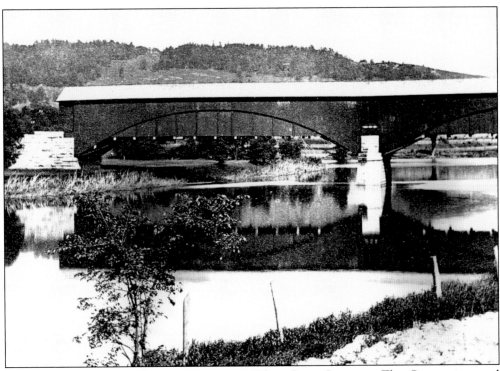

The White River joins the Connecticut at White River Junction. The Connecticut and Passumpsic Rivers Railroad bridged the mouth of the river with this impressive structure. The Burr arch, which is highlighted in the bridge's siding, mark it as a product of designer Henry R. Campbell, although the contractor for the job was Horace Childs and Company. (Richard Sanders Allen collection.)

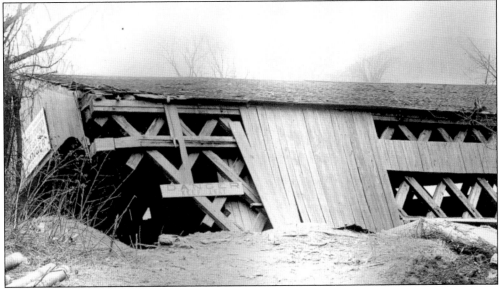

James F. Tasker built a highway bridge across the White River at White River Junction in the late 1860s, using the squared timber lattice he had recently tried in the Cornish-Windsor Bridge. The structure was destroyed in the 1913 flood. (Oscar Lane notebooks.)

Ledyard Bridge connected the locality of Lewiston, in Norwich, with Hanover, New Hampshire, across the Connecticut River. Completed in 1859, it served traffic until it was taken down in 1934. (Richard Sanders Allen collection.)

U.S. Route 5 crossed the Ompompanoosuc River on this covered bridge in the town of Norwich. Bela J. Fletcher built the bridge in 1866, and it was another squared timber lattice truss. It was left standing when bypassed in 1937 but was removed in 1954 because the water level underneath had risen as a result of the new Wilder Dam on the Connecticut River. The site is briefly visible to travelers on Interstate 91. (Raymond Brainerd, July 3, 1939.)

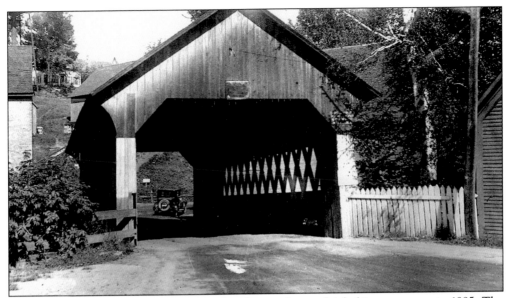

At Quechee, this Town lattice truss replaced an earlier multiple kingpost truss in 1885. The bridge was torn down in the 1920s. In 1970, when Quechee was being redeveloped as an upscale residential center, the concrete bridge in town received a decorative wooden covering. It is not an authentic covered bridge, but it often appears in tourist literature anyway. (Photograph by Basil Kievit; Richard Sanders Allen collection.)

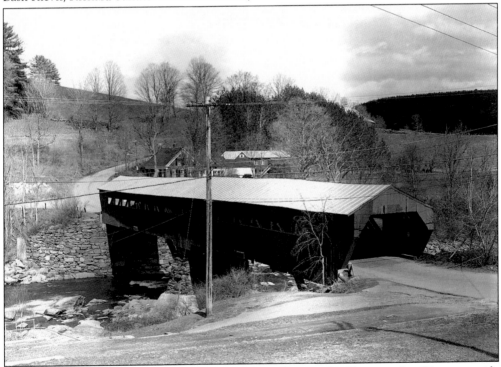

Woodstock's famous Taftsville Bridge still carries traffic over the Ottauquechee River on a side road adjacent to busy U.S. Route 4. It was built in 1836 by Solomon Emmons III. (Joseph D. Conwill, April 13, 1986.)

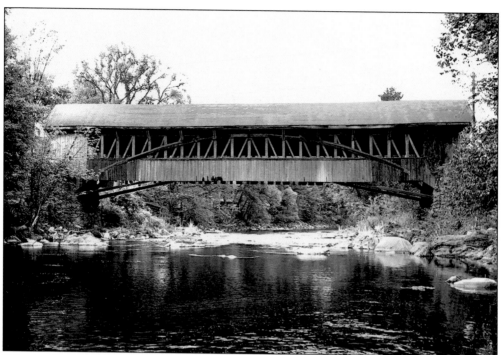

Ephraim Twitchell built this Burr truss covered bridge over the Ottauquechee River at the west entrance to Woodstock village in 1847. It served traffic on U.S. Route 4 until being bypassed with a new bridge in 1938. When it was removed in 1944, the old bridge was still so sturdy that the demolition crew had to blast to bring it down. (Henry A. Gibson, May 29, 1938.)

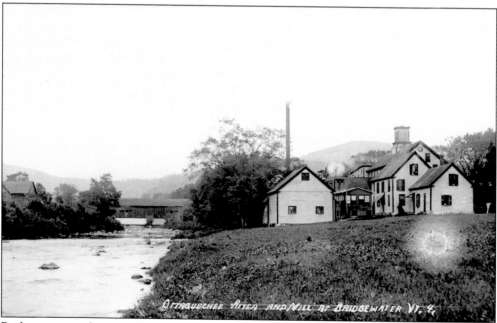

Bridgewater was home to 10 covered bridges, but none are left today. This one, at the village itself, was lost in the 1927 flood. (Author's collection.)

Royalton also had many covered bridges. Broad Brook Bridge, south of South Royalton, was the very last one in town when removed in 1940. (Photograph by Charles Harris; Richard Sanders Allen collection.)

Here is another view of Broad Brook Bridge in Royalton, which was removed in 1940. (Photograph by Mrs. R. W. Williams, summer 1940; Richard Sanders Allen collection.)

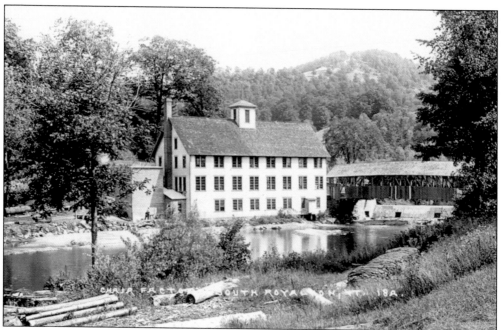

Chair Factory Bridge crossed the First Branch of the White River north of South Royalton until 1937. (Author's collection.)

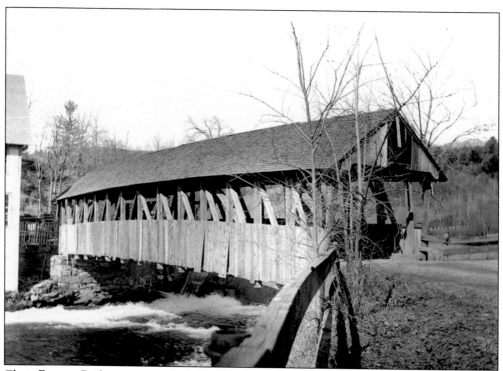

Chair Factory Bridge was typical of the multiple kingpost design used for many bridges in the upland regions of Windsor County. (Richard Sanders Allen.)

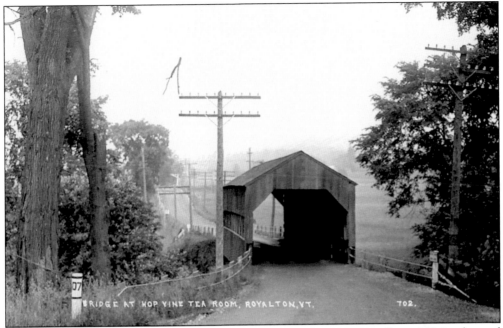

Hop Vine Bridge crossed the Second Branch of the White River on state Route 107, just beyond where it turns off state Route 14 at North Royalton. Note the state highway number painted on the post at the left. (Oscar Lane notebooks.)

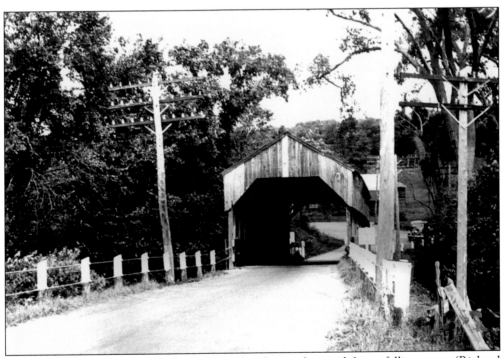

Hop Vine Bridge was replaced in 1937 after being damaged by a falling tree. (Richard Sanders Allen.)

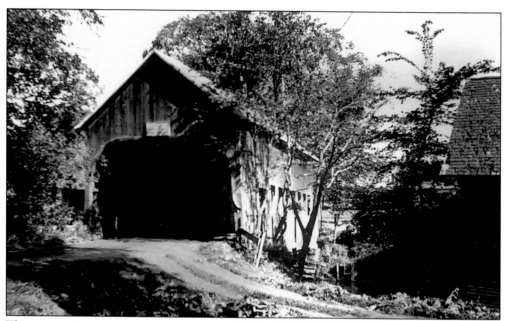

This is one of three covered bridges that once served East Bethel. (Photograph by Basil Kievit; Richard Sanders Allen collection.)

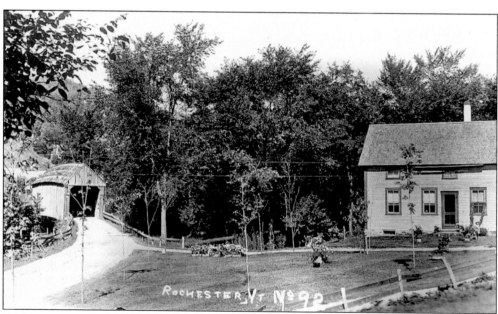

Rochester once had several covered bridges, but little is known of their history. (Richard Sanders Allen collection.)

Five

EAST AND CENTRAL
ORANGE AND
WASHINGTON COUNTIES

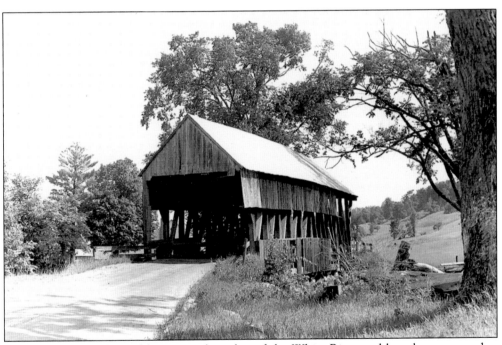

Orange County is drained by various branches of the White River and by other streams that eventually reach the Connecticut River. There were some lengthy covered bridges over the Connecticut itself, but the other rivers are more modest in size and were bridged at every possible crossing. The multiple kingpost truss was popular in Orange County. Washington County is home to Vermont's capital of Montpelier, and the bridge history involves the westward-flowing Winooski River and its tributaries. The area shows the common northern Vermont preference for the Burr truss, but the county saw a variety of other building styles as well. Walter Clark Bridge, shown here, was one of several little multiple kingpost bridges in the upper reaches of the Ompompanoosuc watershed in Thetford. (Raymond Brainerd, July 3, 1939.)

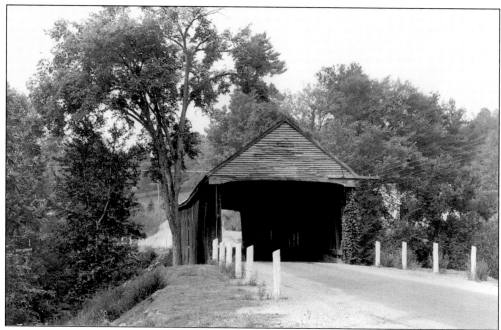

Sayres Bridge, at Thetford Center, uses an unusual variant of the Burr truss once found in three other covered bridges in the region but not elsewhere. The truss braces overlap the panel points, and the arch is framed as an integral part of the structure instead of being bolted across the face of the truss. It is sometimes described as a variant Haupt truss, but the resemblance is merely coincidental. The nearby Bath Village Bridge, in New Hampshire, is the same style and was built in 1832, seven years before the Haupt patent in 1839. (Herbert Richter, August 21, 1958.)

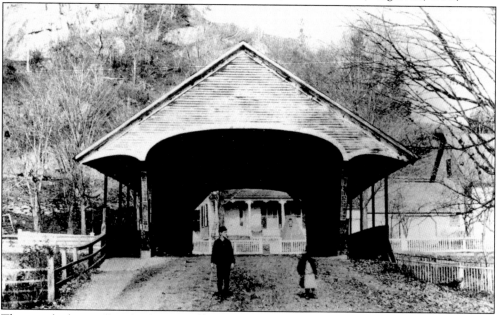

The neat-looking village bridge at Wells River was replaced in 1891. It had a sidewalk on each side, and the portal style showed influence from Caledonia County, farther north. (Caroline Sprague collection.)

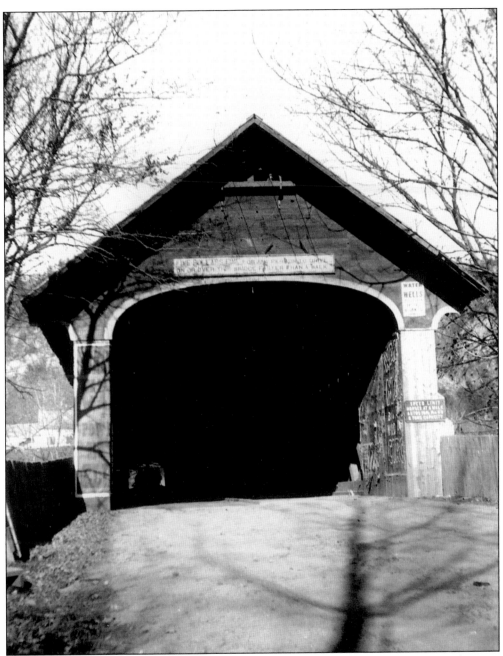

Bridges over the Connecticut River are located mostly in New Hampshire because the state line is the west riverbank, but Vermont can claim a few feet of each one. This bridge was the northernmost of several major bridges that used squared notched timbers in their lattice truss instead of the usual flat planks. It connected Fairlee, Vermont, with Orford, New Hampshire, and was lost in the 1936 flood. (John W. Storrs, November 1, 1922.)

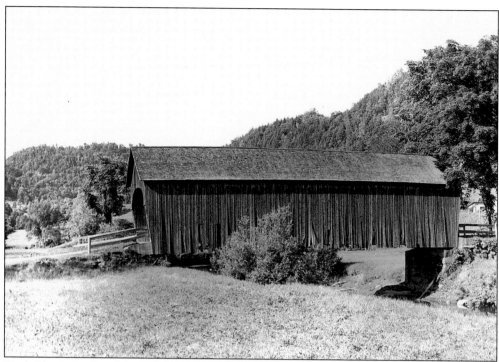

Tunbridge is justly celebrated for covered bridges, with five remaining examples found across the First Branch of the White River and a sixth just over the town line in Chelsea. This is the Howe Bridge, which dates from 1879. (Raymond Brainerd, July 5, 1940.)

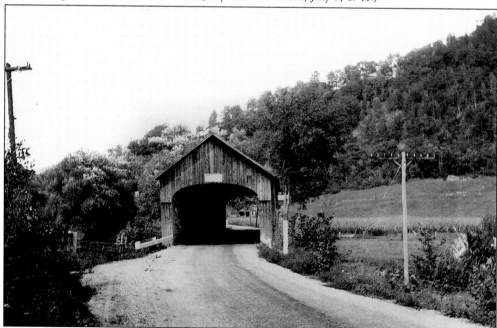

Cushman Bridge spanned the First Branch of the White River in Tunbridge, on state Route 110 between the existing Howe and Cilley Bridges, which are located on side roads. It was replaced in 1938. (Richard Sanders Allen collection, August 1934.)

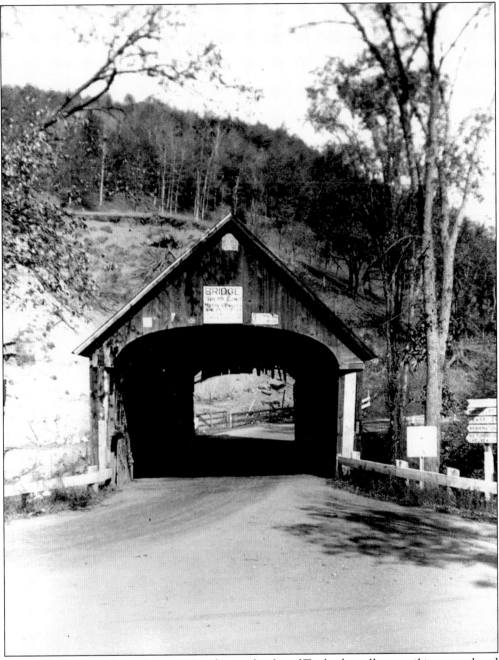

Market Bridge served state Route 110 at the north edge of Tunbridge village until it was replaced in 1938. (Richard Sanders Allen collection.)

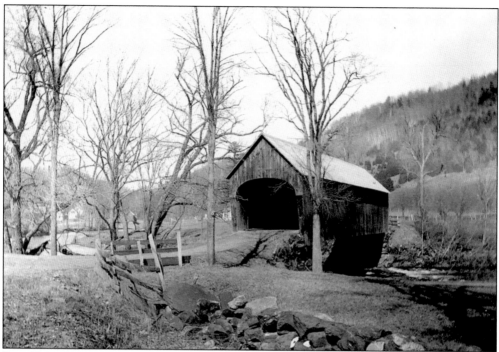

Rowell's Bridge crossed the First Branch of the White River one mile north of Tunbridge. It was washed out during a flood in 1942 and was not replaced. (Richard Sanders Allen collection.)

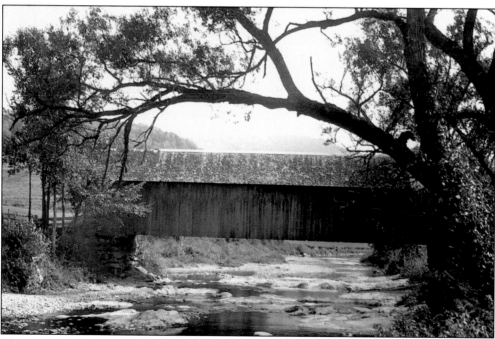

This is another view of Rowell's Bridge in Tunbridge. It was not an important crossing, and its maintenance was partly shared by two local farmers. (Richard Sanders Allen, September 23, 1939.)

Moxley Bridge spans the First Branch of the White River in Chelsea. It was originally located on the main road through the valley, which recrossed the river over the town line in Tunbridge by means of the covered Flint Bridge. The road was relocated in the 1890s, but both covered bridges still remain. (Joseph D. Conwill, April 18, 1993.)

Randolph still has three covered bridges over the Second Branch of the White River. This bridge is located near South Randolph and dates from 1904. (Richard Sanders Allen.)

Upper Bridge, near East Randolph, has only half-height truss work. Thought to have been built in 1904 as an open bridge or a boxed pony truss, it was fully covered five years later. (Henry A. Gibson, June 13, 1948.)

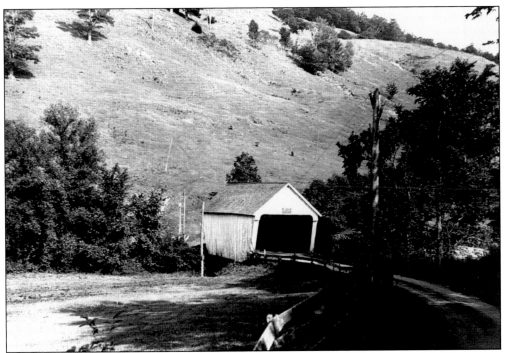

The Lower Bridge, or Gifford Bridge, near East Randolph was once known as the Blue Bridge because it was painted blue, but it has been red for many years now. A timber plantation was set out on the upper slopes of the pasture several years after this photograph was taken. (Photograph by Basil Kievit, 1920s; Richard Sanders Allen collection.)

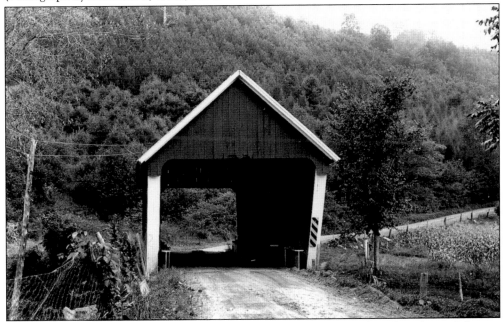

Gifford Bridge has only half-height truss work but is now reinforced with steel beams. In this later view, the hillside in the background has been forested. (Herbert Richter, August 22, 1955.)

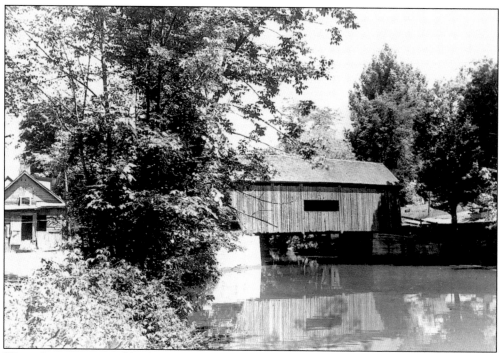

Warren's pretty covered bridge spans the Mad River at the south end of the village and dates from 1879–1880. (Raymond Brainerd, July 6, 1940.)

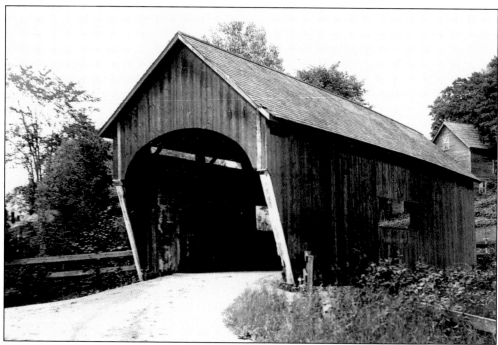

Travelers to Warren have probably forgotten that the portal opening in the old covered bridge was once a graceful elliptical arch. (Photograph by Basil Kievit; Richard Sanders Allen collection.)

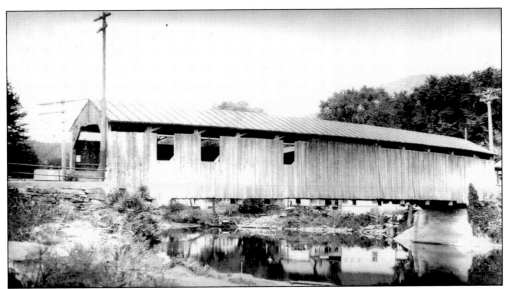

Built in 1833, the Waitsfield Village Bridge is the oldest existing covered bridge in Vermont. This photograph shows it before the sidewalk was added. (Photograph by LaPierre; Richard Sanders Allen collection.)

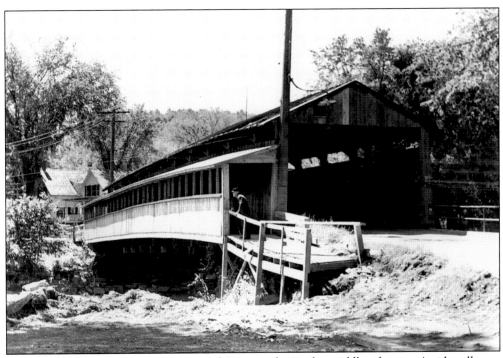

Waitsfield Village Bridge spans the Mad River, right in the middle of town. A sidewalk was added in 1940. (Raymond Brainerd, July 6, 1940.)

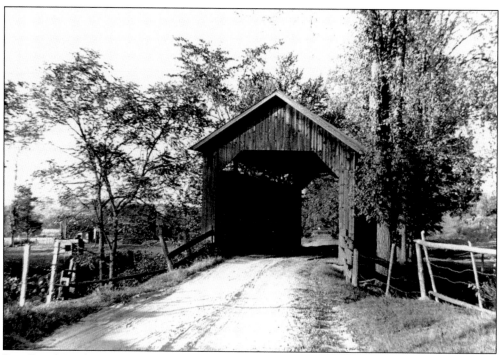

Pine Brook Bridge, north of Waitsfield Common, is a little kingpost truss bridge built in 1872. (Richard Sanders Allen.)

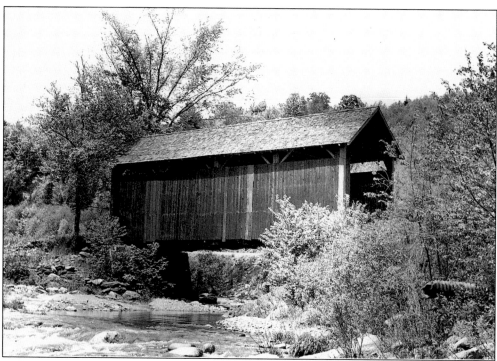

Mill Brook Bridge was one of two covered bridges in the southern part of Fayston, just west of Irasville. (Raymond Brainerd, June 8, 1952.)

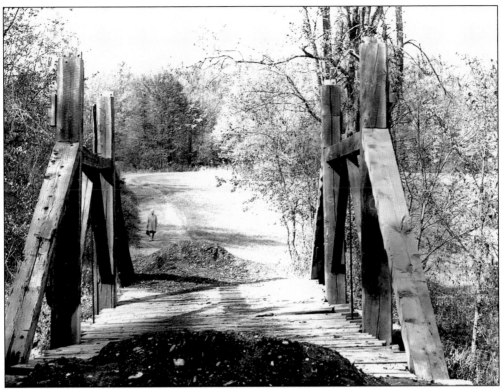

The simple queenpost truss work of Shepard Brook Bridge, near North Fayston, was revealed during removal of the bridge. (Raymond Brainerd, October 14, 1965.)

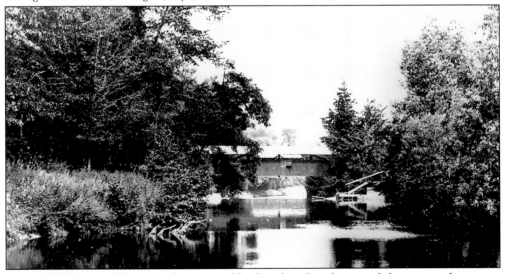

Northfield Falls is still home to four covered bridges, but this photograph has stumped many an expert. It shows the long gone Mrs. Harwood's Bridge, or Gould's Bridge, over the Dog River. It had authentic old timber truss work but was narrow and was used only as a footbridge. The existing Station Bridge is visible behind it. When Mrs. Harwood's Bridge was removed in the 1950s, it was relocated to an island off the shore of Lake Champlain. Its present whereabouts are unknown. (Author's collection.)

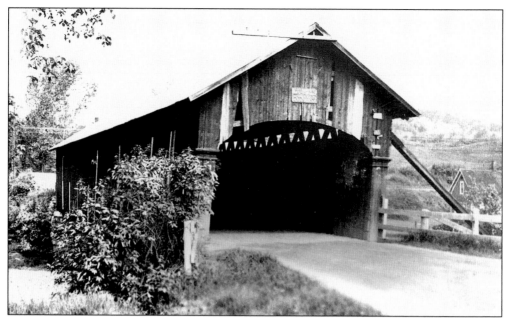

Station Bridge at Northfield Falls is one of a set of triplet covered bridges. Two may be seen from an Amtrak train that passes between them, but the third is uphill and around a corner, just out of sight. Station Bridge was in bad shape when this early photograph was taken. The arched portals have since been squared off at a higher point. (Richard Sanders Allen collection.)

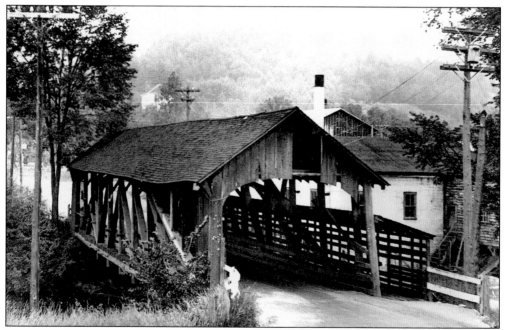

Riverton, also known as West Berlin, had this now long gone covered bridge over the Dog River. The upper chord of the truss followed a rough polygonal arch profile, which is unusual. There was a similar bridge farther south near Irasville. (Photograph by Basil Kievit; Richard Sanders Allen collection.)

This covered bridge spanned the Dog River in Berlin on a quiet side road a few miles south of Montpelier. It collapsed in March 1958 under a heavy load of snow. (Henry A. Gibson, June 14, 1948.)

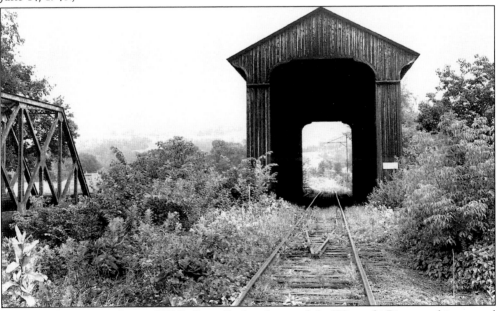

The short line Montpelier and Wells River Railroad crossed the Winooski River on this covered bridge, built in 1904 in the east outskirts of Montpelier. The line was abandoned in 1960. The bridge was dismantled in 1964–1965 and reerected at Clark's Trading Post in Lincoln, New Hampshire. In its new home, it serves a tourist short line and is America's only covered bridge still in use by a railroad. (Herbert Richter, August 22, 1958.)

Orton Farm Bridge, in Marshfield near the Plainfield town line, looks like a junior model covered bridge. Although old and authentic, it was built in 1890 to connect two parts of a large farm and did not have to be as wide as a public bridge. (Raymond Brainerd, September 18, 1940.)

This is another view of Orton Farm Bridge, which is also known as Martin Bridge. (Richard Sanders Allen.)

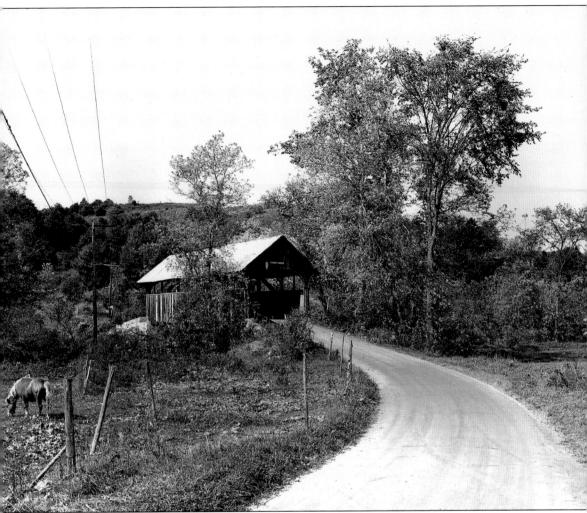

Coburn Bridge spans the Winooski River near East Montpelier. (Joseph D. Conwill, October 3, 1983.)

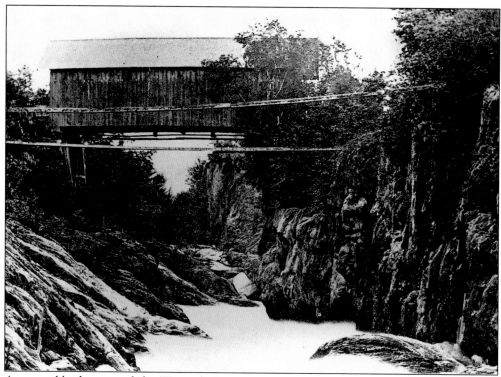

A covered bridge crossed the Winooski River at Middlesex Gorge on what is now state Route 100-B, a road that has since been relocated. Downstream, where the river is wider, there was a long double-barreled covered bridge on U.S. Route 2, but it washed out in the 1927 flood. (Richard Sanders Allen collection.)

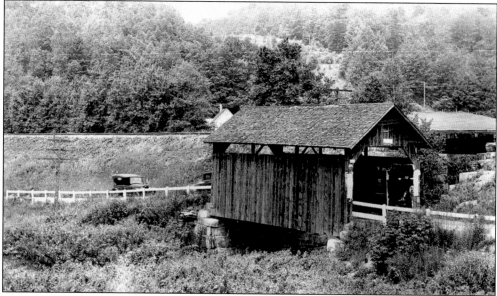

Middlesex also had this diminutive covered bridge, whose location is uncertain. It was probably just east of the village on the main road that became U.S. Route 2. (Photograph likely by L. B. Puffer.)

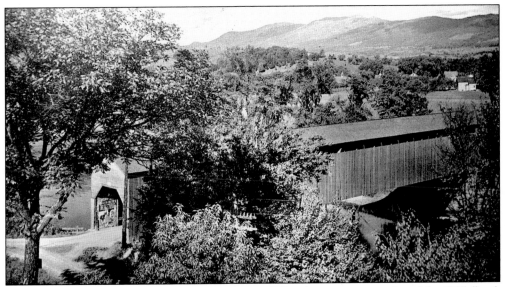

Winooski Street Bridge, located on the outskirts of Waterbury, was a casualty of the 1927 flood. (Margaret Foster collection.)

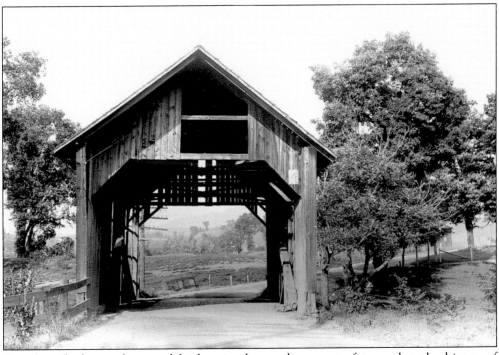

Waterbury had several covered bridges in the northern part of town, but the history of them is little known. This one was located near Kneeland Flat. (Henry A. Gibson, September 13, 1948.)

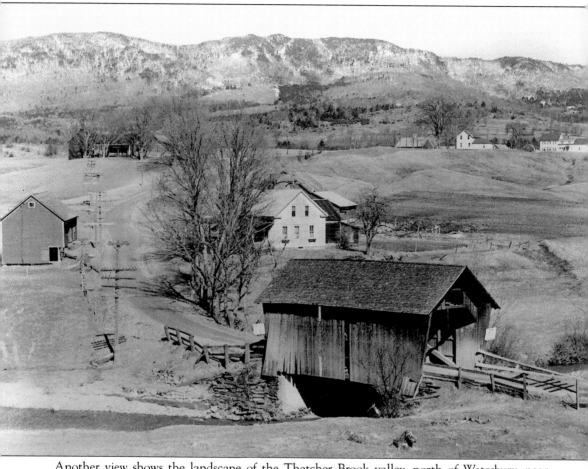

Another view shows the landscape of the Thatcher Brook valley, north of Waterbury, near Kneeland Flat. (Richard Sanders Allen collection.)

Six

NORTHWEST

LAMOILLE AND
FRANKLIN COUNTIES

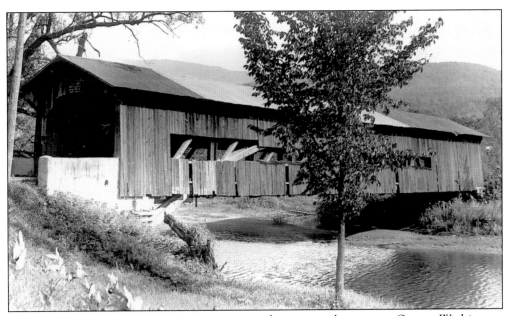

The Lamoille River is the major watercourse of its namesake county. George Washington Holmes and other local builders had a liking for the Burr truss, and the queenpost was widely used for shorter spans. Builders in Franklin County, such as the Jewett brothers, often used the Town lattice truss, though the Burr truss was once found here, too. Both the Lamoille and the Missisquoi Rivers flow through Franklin County on their way to Lake Champlain. Vermont's far northwest corner is Grand Isle County, but here, the streams are small and there were no known covered bridges. Stowe once had 10 covered bridges on various truss plans. Of those 10, one still stands. The local housing style usually had a slight but abrupt portal overhang, which may in some cases have protected an extension of the upper chords of the truss. This example crossed the Waterbury River at the village of Moscow until 1950. (Henry A. Gibson, September 13, 1948.)

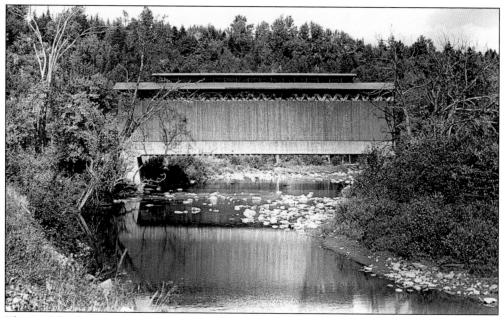

The St. Johnsbury and Lake Champlain Railroad used many covered bridges. Three of them that were located over the Lamoille River in the Hardwick-Wolcott area survived into the 1950s, and one still remains. (Hardwick is in Caledonia County, but since the bridges were near each other, they are considered as a group here.) All three bridges were similar in appearance but different in length. The structure on the roof allowed smoke from steam trains to escape, which lessened the chance of fire. Note that this bridge, east of Hardwick, had a smoke vent of 17 sections. (Raymond Brainerd, September 19, 1940.)

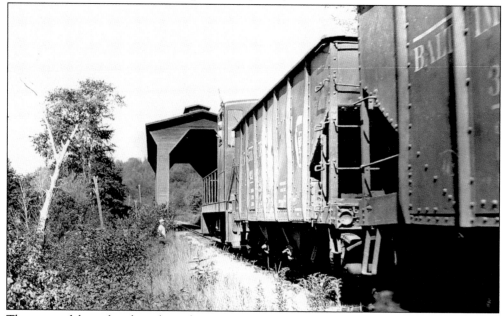

The name of the railroad was later changed to the St. Johnsbury and Lamoille County Railroad, keeping the same initials. Here, an early diesel-powered train crosses the bridge located east of Hardwick, which burned down in 1959. (Henry A. Gibson, September 13, 1948.)

This view of the existing Fisher Bridge, on the St. Johnsbury and Lamoille County Railroad, east of Wolcott, shows how difficult it can be to tell photographs of the three railroad bridges apart. Note, however, that this smoke vent has 11 sections. The third bridge, west of Wolcott, had 19 sections. (Joseph D. Conwill, October 2, 1983.)

Waterman Bridge crossed the brook of the same name about two and a half miles south of Johnson. The main span used a queenpost truss, but there was also a short covered approach span with no truss at all, just stringers under the floor. (Henry A. Gibson, September 13, 1948.)

Downtown Johnson had a little set of twin covered bridges over channels of the Gihon River. Their oversized roofs resembled kites. (Raymond Brainerd, September 6, 1937.)

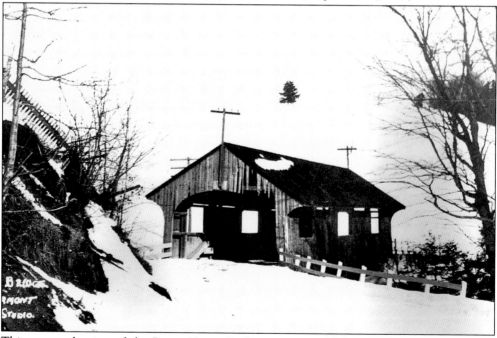

This very early view of the Power House Bridge, just east of Johnson, shows the structure's original arched, board-and-batten portal style, similar to bridges a little farther northwest in Waterville. The portals were long ago modified to an overhung style with no arch. (Photograph by Mills Studio; Richard Sanders Allen collection.)

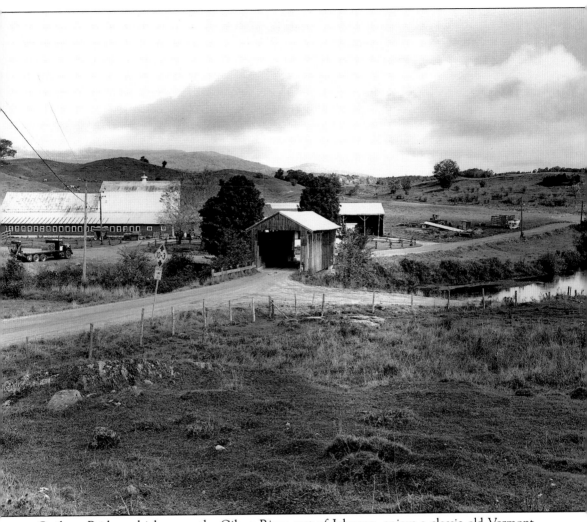

Scribner Bridge, which spans the Gihon River east of Johnson, enjoys a classic old Vermont agricultural setting. The very low truss work has caused speculation that it may have been an open bridge or a boxed pony truss originally. (Joseph D. Conwill, October 2, 1983.)

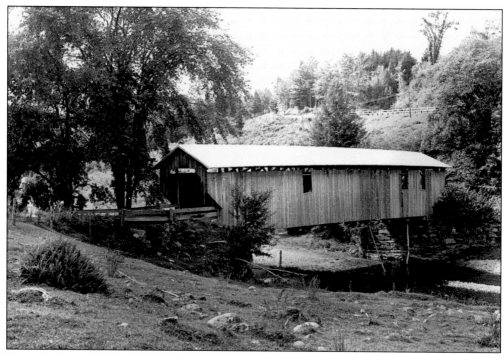

Scott Bridge still carries traffic over the Brewster River near Jeffersonville. It is not to be confused with the Scott Bridge of Townshend, which is closed. (Raymond Brainerd, September 6, 1937.)

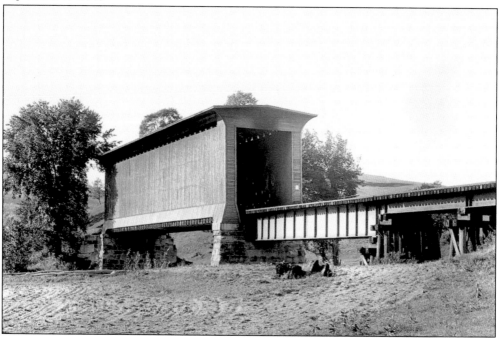

The St. Johnsbury and Lamoille County Railroad crossed the Lamoille River at Cambridge Junction on this covered bridge, which was removed in 1967. The portal was well stained by smoke from passing steam trains. (Henry A. Gibson, September 14, 1948.)

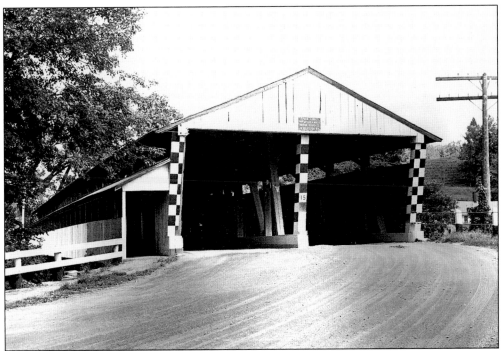

For over a century, the double-barreled Big Cambridge Bridge served the hamlet of Riverside, at the northeast edge of Cambridge village, on what became state Route 15. It was scheduled for replacement in 1950 but was saved and moved to the Shelburne Museum, where it passes a happy retirement as an historical exhibit. (Raymond Brainerd, September 6, 1937.)

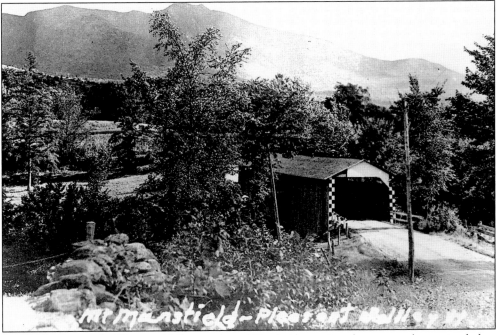

Safford Bridge, in the Pleasant Valley section of Cambridge, enjoyed a spectacular setting below Vermont's highest mountain, Mount Mansfield. (Author's collection.)

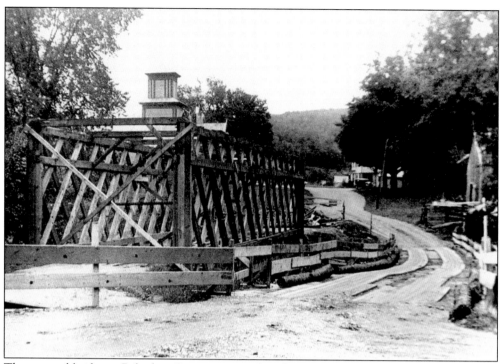

The covered bridge at Belvidere Center is gone, but there are still two covered bridges on side roads in the western part of town. (Richard Sanders Allen, September 1938.)

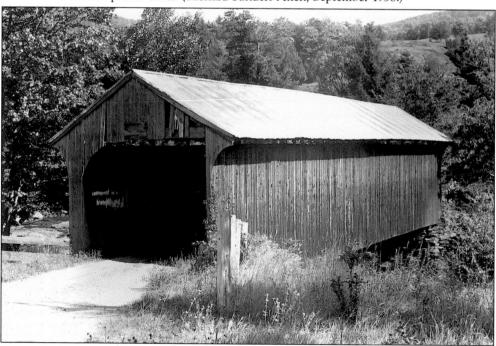

Waterville has three covered bridges over the North Branch of the Lamoille River, also known as the Kelly River. Montgomery Bridge is a little over one mile north of the village and dates from 1887. (Henry A. Gibson, September 14, 1948.)

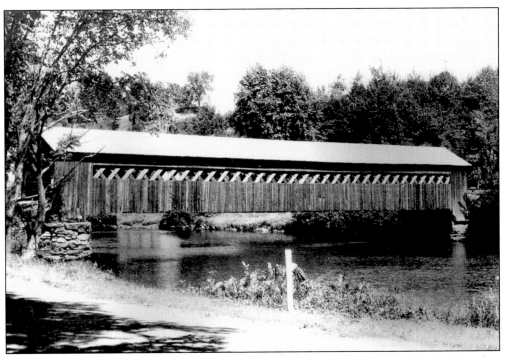

This attractive Town lattice truss crossed the Lamoille River at Fairfax Falls. (Richard Sanders Allen collection.)

Fairfax still has a covered bridge on Maple Street, which dates from 1865. (Henry A. Gibson, September 14, 1948.)

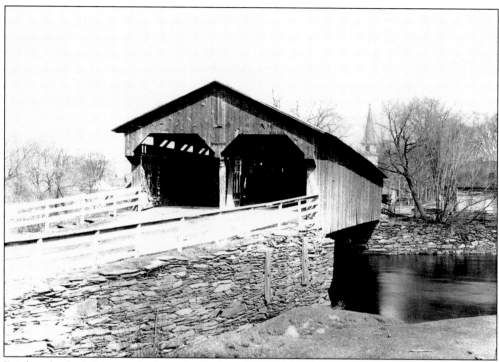

Fairfax also had this neat looking double-barreled bridge, which spanned the Lamoille River at the south end of the village. (Author's collection.)

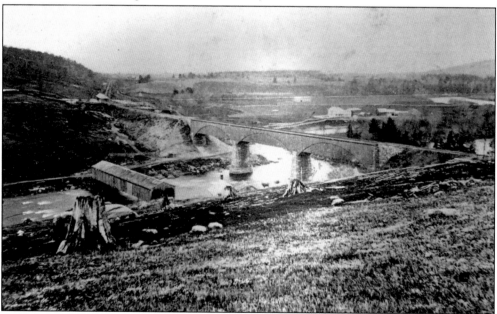

Georgia Station (East Georgia) was home to both a double-barreled highway bridge and a high-level deck truss railroad bridge over the Lamoille River. The siding of the railroad bridge followed the arch of its truss, which was a trademark of famed builder Henry R. Campbell. Note the over-cleared early landscape and the remnant stumps of the "forest primeval." The area was surely more attractive half a century later. (Christine Ellsworth collection.)

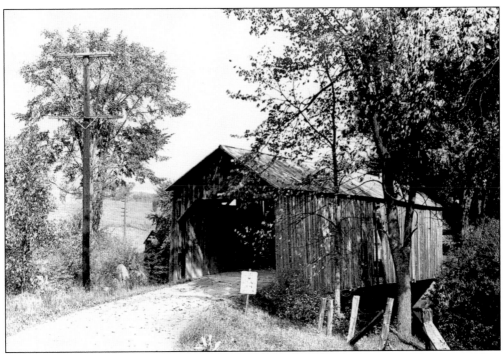

East Fairfield's covered bridge dates from 1865 and still exists today. However, it has been closed for many years now and is in poor condition. (Raymond Brainerd, September 30, 1950.)

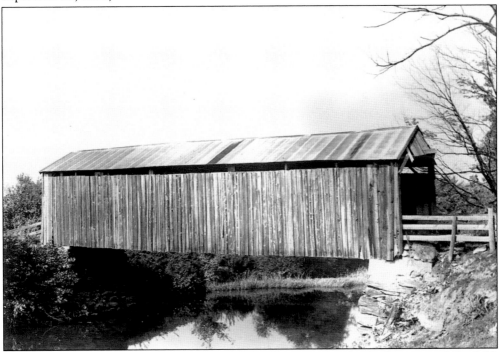

This old bridge served the curiously named locality of St. Rocks in the town of Fairfield. (Raymond Brainerd, September 30, 1950.)

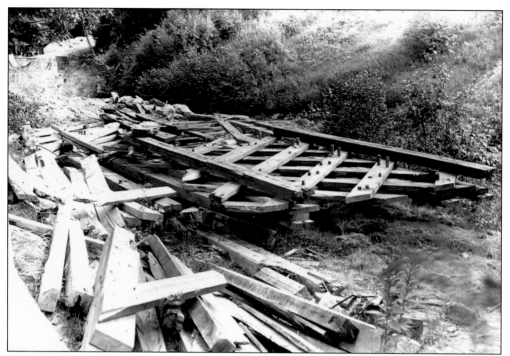

Covered bridge preservation was not yet an accepted idea in the 1940s. When the photographer visited the Shingle Mill Bridge near East Enosburg, he found only these remains. (Henry A. Gibson, September 15, 1948.)

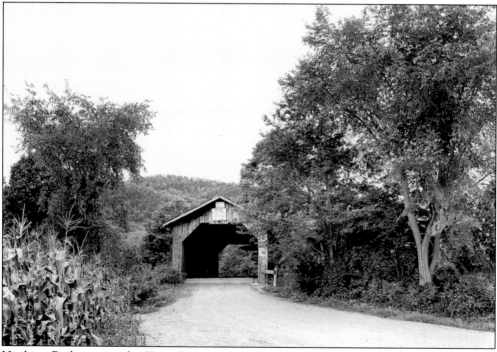

Hopkins Bridge spans the Trout River in Enosburg, almost on the Montgomery town line. (Joseph D. Conwill, September 7, 1985.)

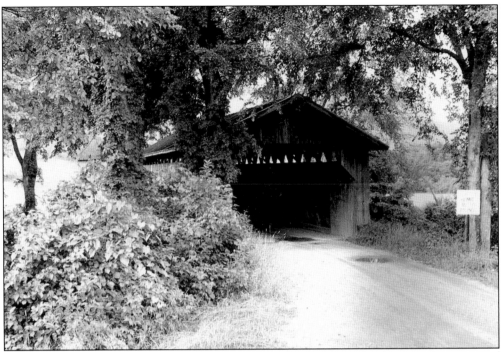

Montgomery is still a big covered bridge town. Longley Bridge crosses the Trout River west of the village, but the road has been straightened and trees no longer shelter the bridge. (Herbert Richter, August 10, 1956.)

These two bridges served state Route 118, just west of Montgomery. Charlie Clapp Bridge, located over the Trout River, is seen from inside Levis Bridge on West Hill Brook. (Richard Sanders Allen.)

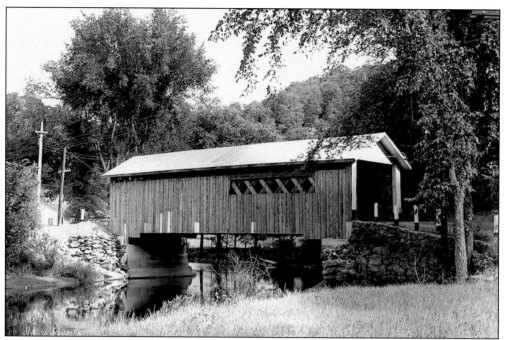

Comstock Bridge also served Route 118 in Montgomery between Levis Bridge and the village center. The highway was relocated to straighten a curve, but the 1883 covered bridge still carries traffic on the old road. (Raymond Brainerd, August 11, 1941.)

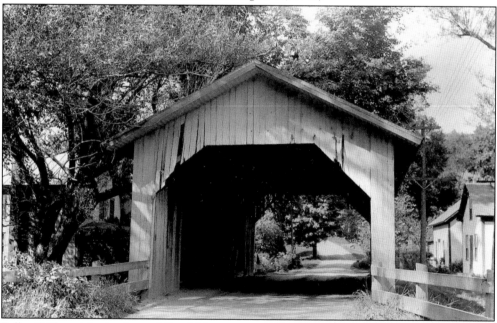

Fuller Bridge, right in the middle of Montgomery village, was built by Sheldon and Savanna Jewett in 1890. The brothers lived locally and built all of the other existing covered bridges in town. Fuller Bridge served for 110 years, but the trusses on one side suffered repeated flood damage. In 2000, it was torn down and replaced with a new replica of similar construction. (Henry A. Gibson, September 15, 1948.)

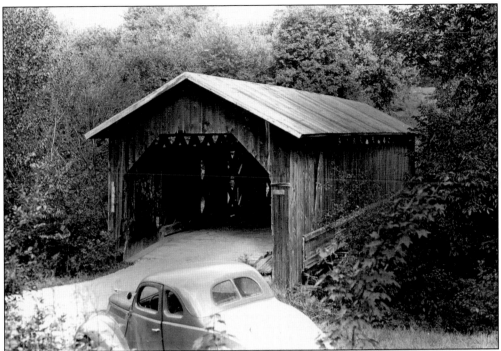

Hutchins Bridge still spans the South Branch of the Trout River, a little over one mile south of Montgomery Center. The eastern end formerly rested on a streamside ledge outcrop, but this interesting natural abutment is now encased in a wall of concrete. (Henry A. Gibson, September 15, 1948.)

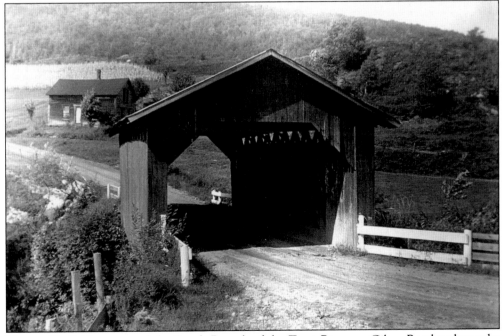

Hectorville Bridge spanned the South Branch of the Trout River on Gibou Road and was the next crossing south of Hutchins Bridge. (Richard Sanders Allen.)

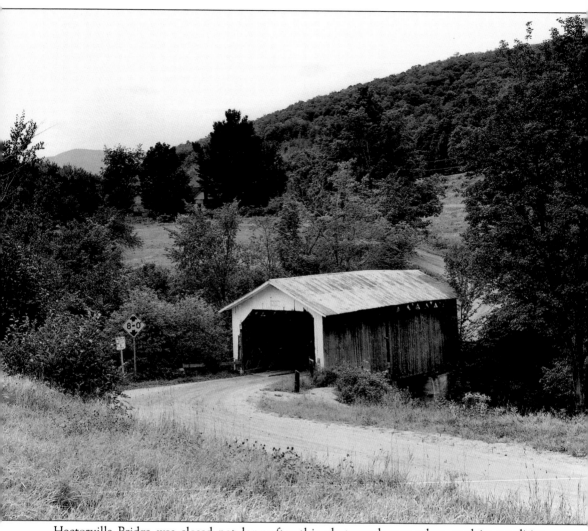

Hectorville Bridge was closed not long after this photograph was taken, and its condition gradually worsened. In 2002, it was removed and placed in storage for possible rebuilding at a less isolated location. (Joseph D. Conwill, August 19, 1984.)

Seven

NORTHEAST
ORLEANS, CALEDONIA,
AND ESSEX COUNTIES

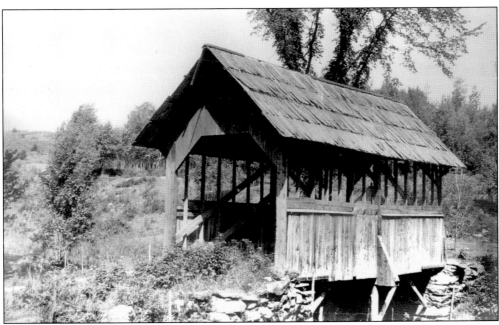

Peter Paddleford of Littleton, New Hampshire, designed a truss type once popular throughout northern New England. Northeastern Vermont was the western end of its range. For longer spans it largely took the place that the Town lattice or Burr trusses held elsewhere in the state. As usual, the queenpost truss was popular for shorter spans. Most of the rivers of Orleans County drain north into Lake Memphremagog and, from there, into the St. Francis watershed in Canada. However, the western edge of the county is part of the Missisquoi system, and in this locality, a variant of the Town lattice truss held sway. In Caledonia and Essex Counties, most of the waters reach the Connecticut River. The almost tropical-looking modified kingpost bridge shown here served far north Jay, Vermont, west of the village. At the time, this was only a local road, but it is now state Route 242. (Richard Sanders Allen collection.)

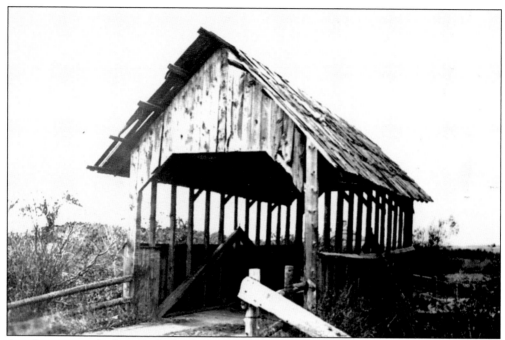

Another strange-looking little bridge stood north of Jay. It was replaced in 1937. (Richard Sanders Allen collection.)

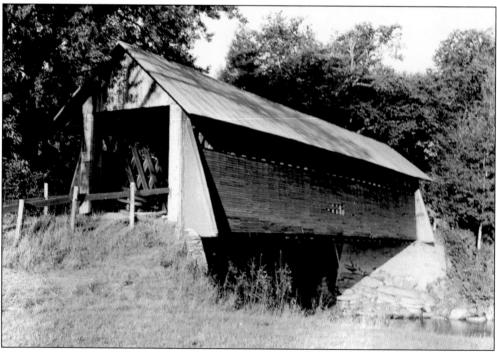

The Limonges Farm Bridge crossed the Missisquoi River on a private road just outside North Troy until it collapsed from neglect in 1957. It was also known as the Lower Bridge, which confused some early writers. The river flows north here, so the Lower Bridge was north of the existing Upper Bridge. (Henry A. Gibson, September 15, 1948.)

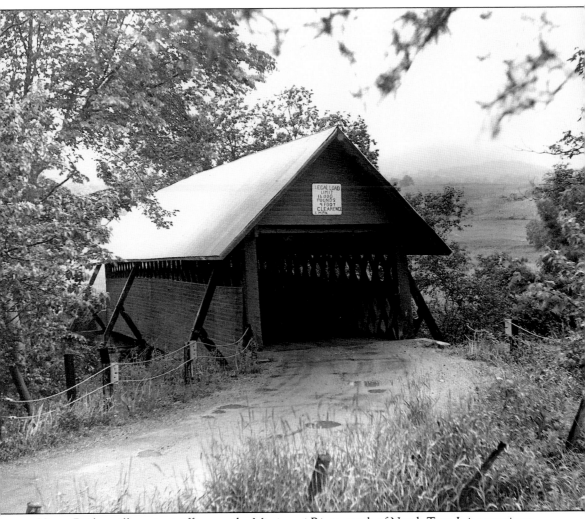

Upper Bridge still carries traffic over the Missisquoi River, south of North Troy. It is sometimes called the River Road Bridge, but it is not quite located on River Road. It is the area's last remaining example of a local Town lattice variant using only a single treenail to peg the web joints, rather than the usual two. There is another located just over the line in Canada at Province Hill. (Joseph D. Conwill, June 13, 1982.)

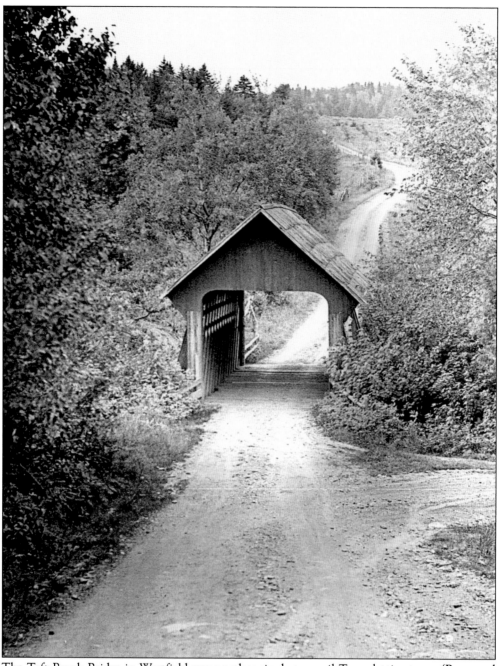

The Taft Brook Bridge in Westfield was another single treenail Town lattice truss. (Raymond Brainerd, September 20, 1940.)

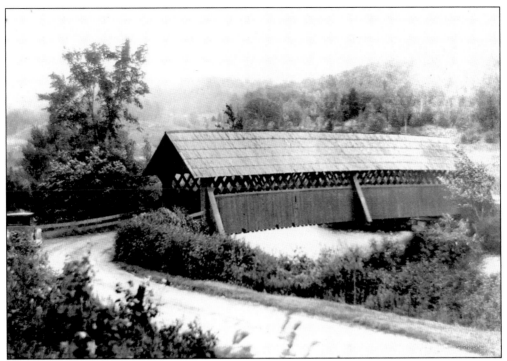

Phelps Falls Bridge in Troy was lost in the 1927 flood. It appears to have been an example of the local single treenail Town lattice truss. (Photograph by Richardson Studio; Richard Sanders Allen collection.)

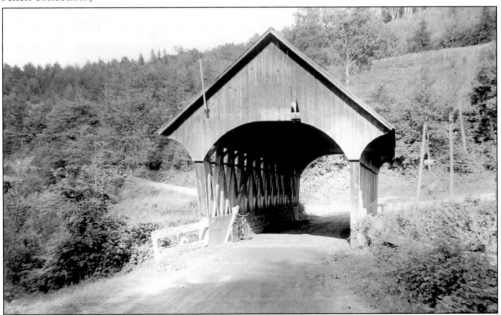

Albany begins the territory of Paddleford truss influence. In bridges such as this one at the western edge of the range, the counter ties were usually flush with the inside face of the posts and braces; elsewhere, the counter ties were usually treenailed across this plane and only slightly notched in. (Richard Sanders Allen.)

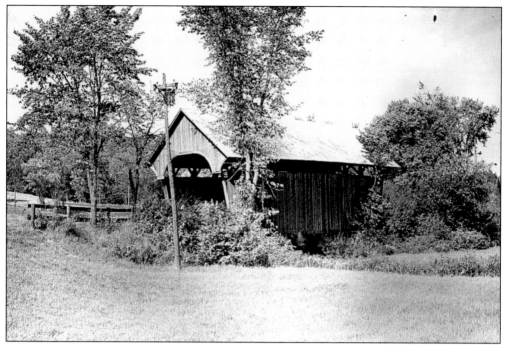

Lord's Creek Bridge in Irasburg was replaced in 1958 and was moved to a nearby farm, where it now spans the Black River. Unfortunately, the siding was left off, and the trusses were set directly atop the new abutments without bed timbers to protect them from decay. Thus, the bridge is now in poor condition. (Raymond Brainerd, September 20, 1940.)

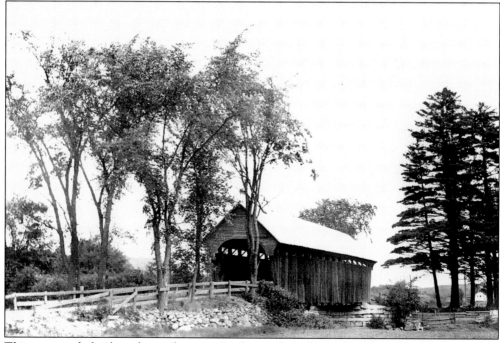

This covered bridge, located near Irasburg, lasted until 1938. (Richard Sanders Allen collection.)

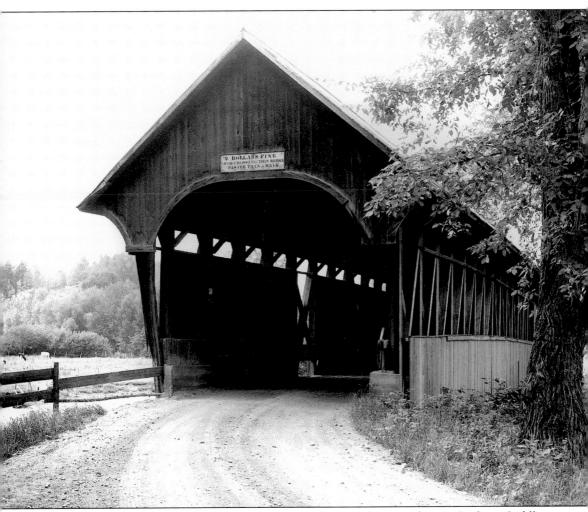

Black River Bridge, just south of Coventry, was really over the town line in Irasburg. It fell victim to arson in 1997 and was replaced with a new covered bridge two years later. (Herbert Richter, 1957.)

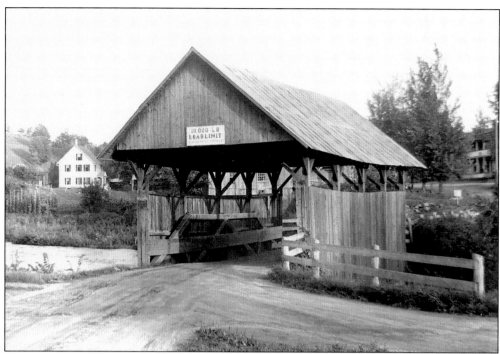

West Charleston's well-ventilated covered bridge crossed the Clyde River until 1947. (Richard Sanders Allen.)

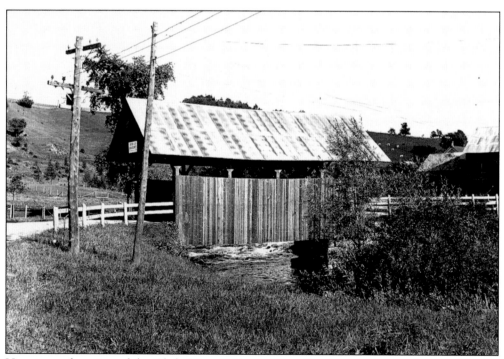

Here is another view of the Clyde River Bridge at West Charleston. A second covered bridge nearby was replaced two decades earlier. (Raymond Brainerd, September 7, 1937.)

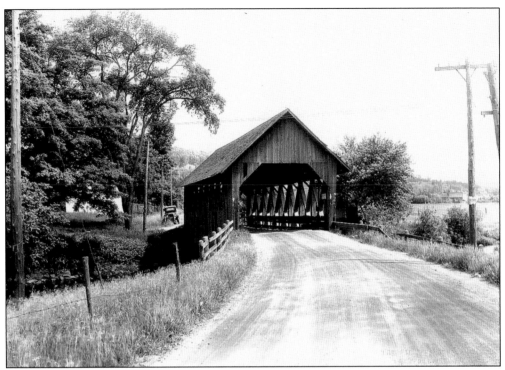

This bridge is thought to have spanned the Clyde River on state Route 105, southeast of West Charleston between Lubber Lake (Charleston Pond) and Pensioner Pond. (Photograph by Richardson Studio; Richard Sanders Allen collection.)

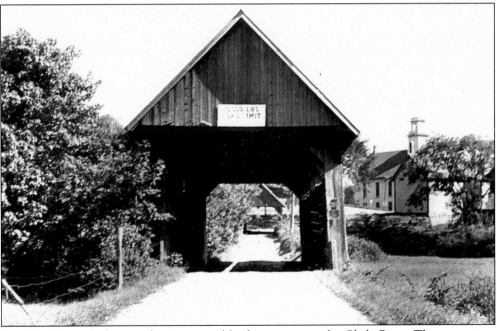

East Charleston had a set of twin covered bridges spanning the Clyde River. They were torn down in 1947. (Raymond Brainerd, September 7, 1937.)

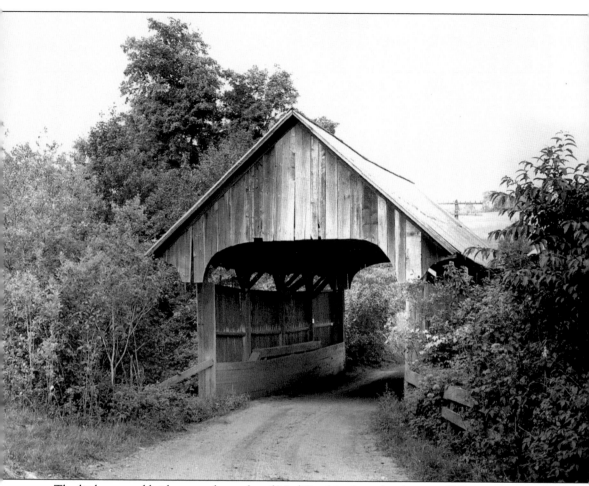

The little covered bridge over the outlet of Mud Pond in the upland town of Morgan was noted as Vermont's highest above sea level, at 1,456 feet. It was built in 1889 by Lorenzo and Osborne Farr and replaced by a culvert in 1958. (Herbert Richter, 1957.)

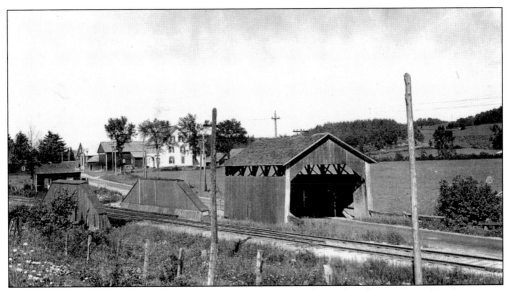

The covered bridge between East Hardwick and Greensboro Bend was directly adjacent to a boxed pony truss on the St. Johnsbury and Lamoille County Railroad. (Richard Sanders Allen collection.)

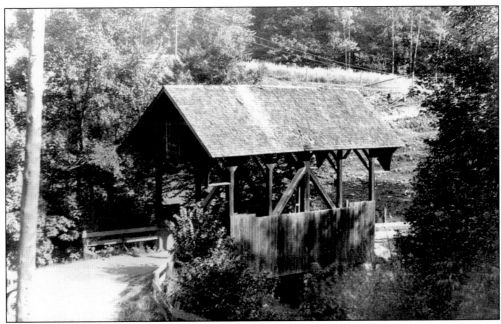

This old covered bridge, located in the town of Danville, was so small that it looked like a toy model. (Richard Sanders Allen collection.)

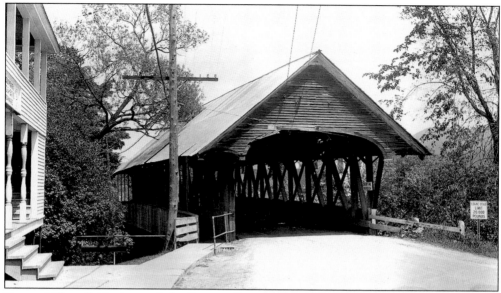

Barnet Village Bridge crossed the Stevens River right in the middle of the village. It was a Paddleford truss, and the graceful arched portals with their narrow horizontal clapboards are also thought to trace back to Peter Paddleford's style. (Henry A. Gibson, June 17, 1948.)

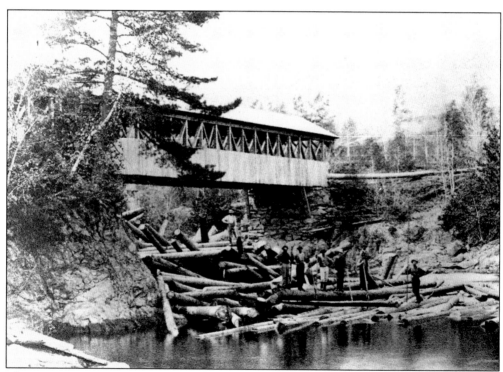

This is a pre-1877 view of the Paddleford truss bridge located over the Connecticut River at Beard's Falls, between Barnet, Vermont, and North Monroe, New Hampshire. The bridge was longer than it appears, as part of it is hidden by the promontory at the left. (Richard Sanders Allen collection.)

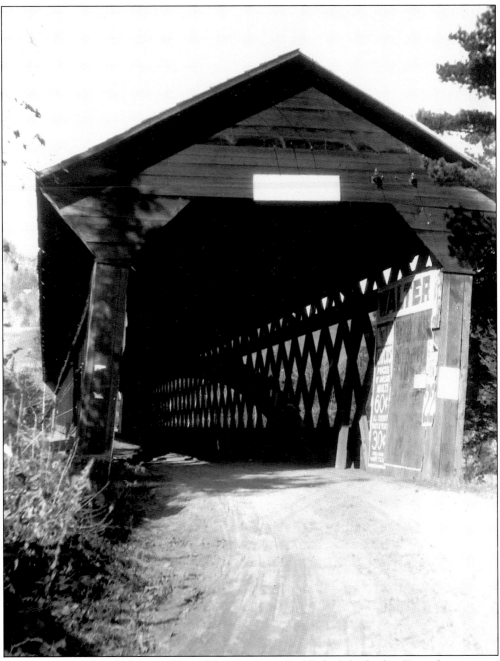

Philip Henry Paddleford, son of famed builder Peter Paddleford, built this Town lattice truss replacement of the Beard's Falls Bridge in 1877. It lasted just over 60 years. (John W. Storrs, October 31, 1922.)

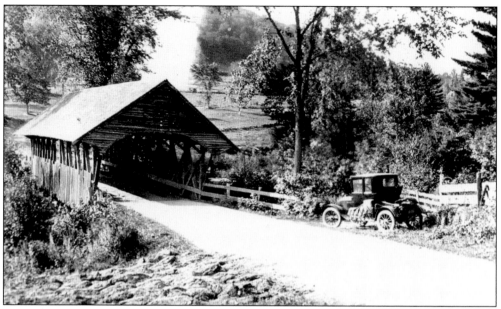

Lower Waterford's covered bridge had a Paddleford truss with an odd open center panel. It was torn down in 1929. (Richard Sanders Allen collection.)

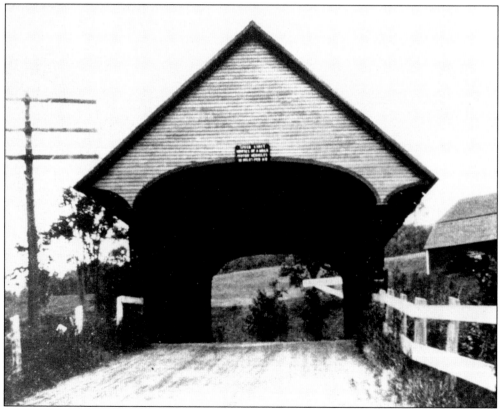

Works Bridge, east of St. Johnsbury, spanned the Moose River on U.S. Route 2, just west of its junction with state Route 18. (Richard Sanders Allen collection, August 1927.)

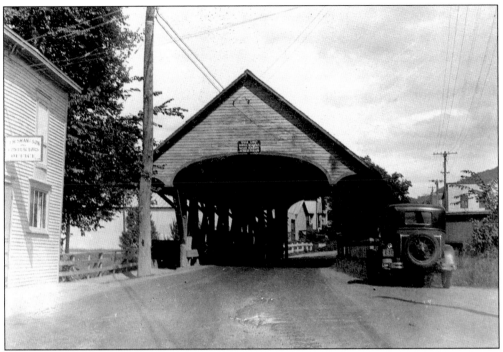

Portland Street Bridge, another St. Johnsbury crossing of the Moose River on U.S. Route 2, was located in the east end of the city. (Richard Sanders Allen.)

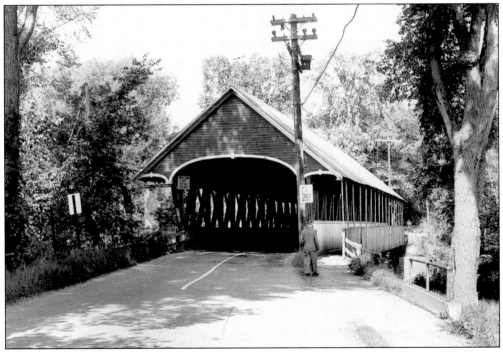

Sanborn Bridge spanned the Passumpsic River between Lyndonville and Lyndon Center until 1960. When a new bridge was built here, the covered bridge was moved about one mile upstream, where it still spans the same river on private property. (Herbert Richter, 1957.)

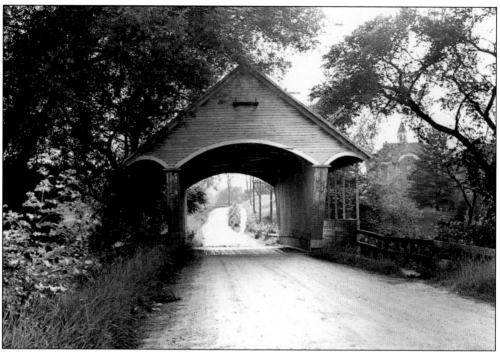

Schoolhouse Bridge, located on the edge of Lyndon, is tightly boarded inside and out, so that the truss is completely hidden. It is usually described as a queenpost truss, but some who have seen behind the boarding say that it is really a kingpost truss. (Raymond Brainerd, July 22, 1938.)

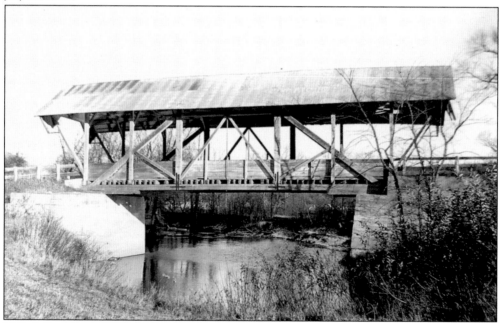

Miller's Run Bridge still stands on a spur of state Route 122 north of Lyndon Center, although it has been hit by trucks many times over the years and not much is left of the original bridge. (Richard Sanders Allen.)

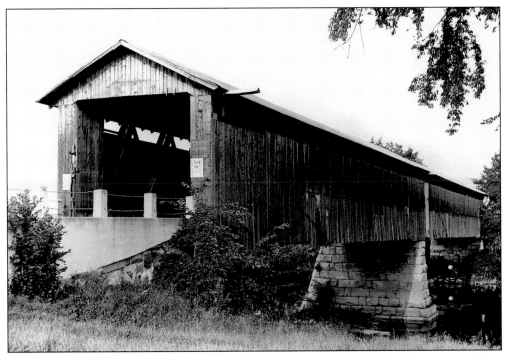

Bridge Street Bridge, or Lancaster Bridge, was an interstate crossing of the Connecticut River between Lancaster, New Hampshire, and the southern edge of Guildhall (in the old days, pronounced with the *d* silent, "Gilhall"). It was built in 1901 by the Berlin Construction Company, a firm usually noted for iron and steel bridges. Originally, the sides were boarded only halfway up, but later they were boarded higher. (Henry A. Gibson, August 28, 1948.)

Bridge Street Bridge served the traffic on busy U.S. Route 2 until it was replaced in 1950. (Richard Sanders Allen collection.)

Crete Farm Bridge served private property in Canaan but was a genuine old covered bridge dating from 1927. It collapsed *c.* 1959 and was always little known; thus, photographs are scarce. (Herbert Richter, 1957.)